MW00804878

The New Zealand Cat

The New Zealand Cat

RACHAEL HALE McKENNA

Stories written by Kimberley Davis

ALLEN&UNWIN
SYDNEY・MELBOURNE・AUCKLAND・LONDON

For all the cats we have loved,
who we still love, and for those
we will love in the future.

Introduction

Cats have always been really important to me. When I was a child, our first family cat, a classic brown tabby called Twinkle, gave birth to a litter of kittens at the foot of my sister's bed, and from this litter came Tiger, then Bubbles and Squeak, followed by Sebastian, Dominic and Chloe. Some cats stay in our lives longer than others, and some embed stronger footprints in our hearts than others, but they all leave us with fond memories of the time they shared—or should I say ruled?—our lives.

I have loved all the cats who have shared my life, but one in particular managed to engrave himself into the souls of everyone who met him. He even converted cat haters into cat lovers—well, into Eddie lovers! Edmund, more commonly known as Eddie, was my arrogant, cheeky, naughty, greedy and *extremely* scruffy and dirty Himalayan Persian. He entered my life one day when I was taking photographs for the Auckland SPCA. As I walked into the reception area, I saw an adorable little fluffball strolling along the front desk. I soon learned that this was Hillary, one of two kittens who were the only survivors of a litter born from a neglected breeding cat. I was *smitten*. 'Is the other kitten up for adoption?' I asked, and was thrilled to hear 'yes!' in response.

Upon discovering that Hillary had been named after Sir Edmund Hillary, the first mountaineer to reach the summit of Mt Everest, I knew that my newly adopted little boy could only rightly be named Edmund. But Edmund didn't exactly follow in his namesake's footsteps: he was the clumsiest climber known to the cat world, and his best efforts took him to the top of the couch, where he would race back and forth, teasing my Newfoundland dog, Henry. He sometimes even used Henry as a

stepping stool to get up to higher ground.

Eddie became quite well known in Ponsonby, the central Auckland suburb where I lived at the time. His local hangout was the Nosh grocery-store carpark, where he would wait patiently at the door for the locals to give him pats and feed him treats. Shredded chicken was his absolute favourite! Even an afternoon of heavy rain didn't stop Eddie from heading up the road for his afternoon food fix. I would often come home from my studio to find him sitting in the middle of the road, dripping wet and covered in wet leaves, snails, slugs and dirt, simply expecting the cars to drive around him—which they did, thankfully. Luckily it wasn't a busy street at the time, and all the neighbours knew him and were happy to heed his rules and expectations. Eddie adored the outdoors and was always getting dirty, so I had to teach him while he was still a kitten to get used to the shower. I would joke that he should never have been born a Persian! It became so hard to manage that, in the end, I would get his fur clipped. Every couple of months, he would go off to the local dog groomer and sit among the dogs, with the same permanently grumpy expression on his face, getting his fur trimmed. He always looked adorable on his return—a big, boofy head, tail and feet, and a tiny little body. My little Ewok!

When it came to photographing the cats for *The New Zealand Cat*, I had to take a rather different approach from my previous book, *The French Cat*. While roaming the streets of France, I had come across cats everywhere: they were in every little lane, sitting on window sills, lazing on the tops of walls, curled up on doorsteps, and were always keen for a pat and a play with

my feather toys. It was often quite easy to encourage them to follow me down the road to a slightly better and more photogenic setting.

Photographing these New Zealand cats was a completely different experience. For a start, if I wandered the streets of New Zealand, I might perhaps come across a few cats, but most would disappear rapidly to the safety of their comfortable homes if I approached them. So the hunt began. I sought out cats with interesting stories, then went to their environment to try to capture a stunning portrait of them (hopefully). As we all know, cats have their own agenda, their own rules, so even if some of the cats I found had fantastic stories they wouldn't necessarily agree to having their portrait grace the pages of this book! Thankfully, I seem to have a way with cats, so most of my chosen subjects allowed me to capture

their photographs—though sometimes it took more than one or two attempts, and some cats were, I must admit, a little less than enthusiastic and left me no choice but to capture a grumpy expression. At least Eddie had given me plenty of practice with that!

I have met some wonderful cats during the time it has taken me to create the images for this book. There have been some real characters and extroverts, and others who were more gentle and withdrawn, and each and every one of them has added something special to the pages of this book. I hope that their stories touch your hearts as they have mine.

Rachael Hale McKenna
November 2017

Boo Boo
and
Johnny Boy

Half-brothers Johnny Boy (left) and Boo
Boo (right) came to the farm they now call
home with a warning from the breeder:
'These exotic tabbies are of high breeding
and sensitive dispositions, and terrible
trouble will almost certainly ensue if they
are allowed to venture outdoors. Best they
stick to an inside life.'

The only thing is, nobody told Johnny
Boy or Boo Boo that.

These two took to the wild life with
gusto, and can often be found helping
their humans round up the cattle and
trim the horses' hooves, or frolicking with
great abandon across the paddocks. They
might be farm cats, but they'll never have
a whisker out of place; these exotics, whose
claim to fame is 'being adorable', are
always camera-ready.

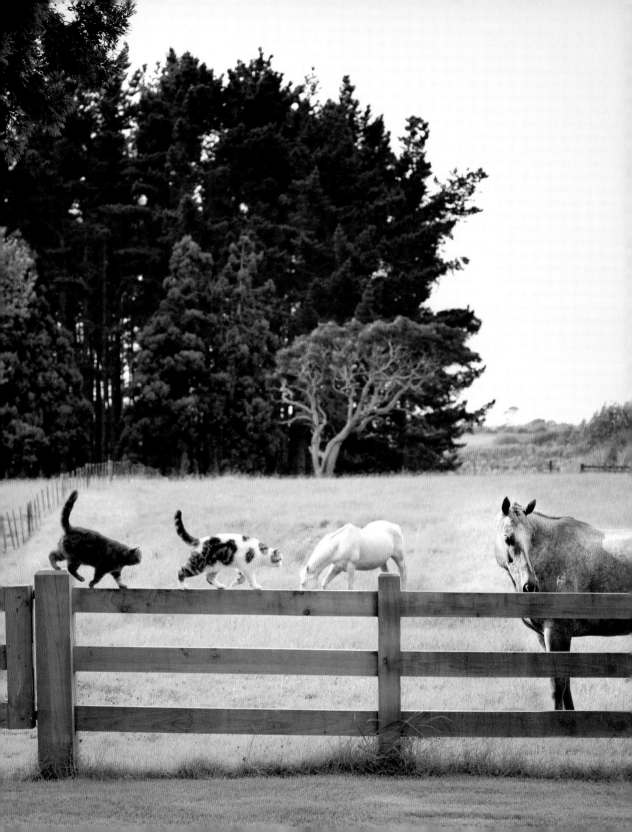

Boo Boo, the exotic blue tabby (he's the grey one), gets his name from his capacity to play peek-a-boo endlessly. He loves nothing more than snuggling up on the sofa, and will sprawl out on his back, legs high in the air and tongue poking out of the side of his mouth, ready for affection from his humans. Boo Boo loves the limelight, and will don a cowboy hat and sweater, then perform tricks in return for treats and attention.

Johnny Boy, the exotic silver tabby, is the watchman of the pair. He'll stealthily patrol the perimeter of his eight-acre rural domain, and has kept a vigilant eye on his cheeky brother since day dot. He often sits in the driveway, patiently observing everything, with his front legs crossed in front of him.

Johnny Boy is a dude: rather like John-boy of *The Waltons* fame, he is quiet, thoughtful and ever so resourceful and caring.

Come the shorter, colder days of winter, the brothers will retire indoors to bask in the heat of the fire. They follow their humans everywhere, and can always be relied upon to pop up wherever the action is. These cats live a blessed, idyllic life indeed, but their humans feel equally lucky to have their furry companions by their sides—even when that means waking up to find that two fluffy bundles have claimed prime position in the bed (simple solution: they just got a bigger bed!).

Mrs Fisher

Local legend has it that former stray
Mrs Fisher's eye was damaged by a
fish hook. She is a funny wee cat who
becomes quite affectionate—and even
a bit bossy—as soon as she feels settled.

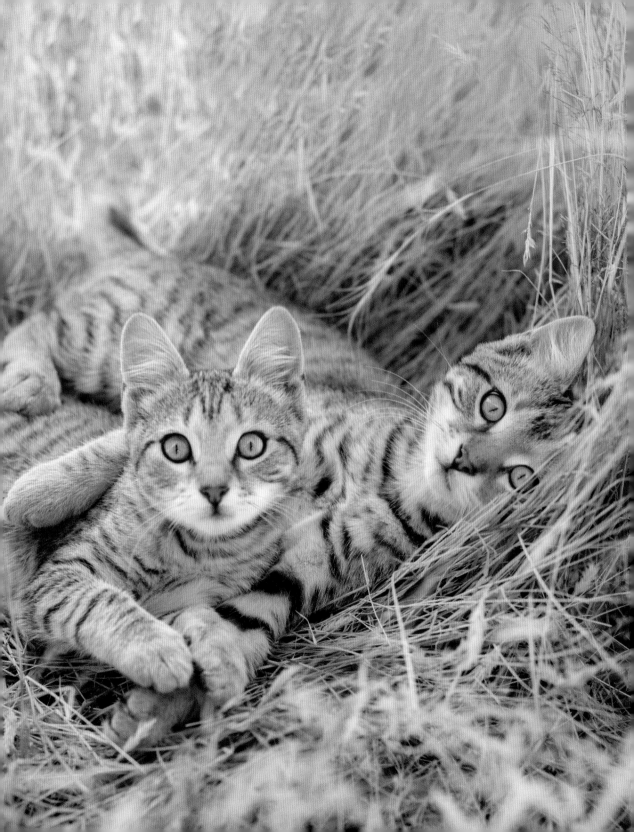

Tiger
and
Coco

This adorable brother and sister found themselves orphaned and alone in the world before they were old enough to be away from their mother. Luckily for them, their mum had given birth to them in a kind farmer's shed, and the farmer and his wife stepped in and cared for the kittens until they were ready to be weaned and fostered out to a local family. Cheeky Tiger and Coco are super-friendly little cats, always up for adventure and totally unafraid of anything—even their family's dogs, including little Flash who is pictured here.

Tiggs

Meet Tiggs—aka Fatty Arbuckle or Tiger Belly—a happily rotund ten-year-old tabby. Right from kittenhood, she's always been fond of her food and will do anything if there's an edible treat in it for her. She waddles gracefully around her domain, her hearty belly swinging from side to side, and disperses happiness wherever she goes. She's a bit of a heavy breather, even when she's not doing anything but sitting and contentedly watching the world go by, and she even snores at night. On more than one occasion, her owner has blamed her partner when it's actually Tiggs whose drowsy sighs are echoing through the dark house!

Bear and Misty

Misty's soon-to-be family were displaced by the February 2011 Christchurch earthquake. In the aftermath, they wisely decided that a good remedy to the awful shock of the earthquakes and the stress of being uprooted from their home—in particular, for their twelve-year-old daughter—would be a kitten.

Their daughter diligently saved her pennies and soon adopted beautiful Misty, the Birman ragdoll. Misty is never far from her favourite family member, and always keeps a close watch over everyone. She's quite the mother of the family—and, indeed, as soon as she was settled into her new abode she gave birth to her own litter of little cuties. The family kept one of her babies, a black kitten they named Bear.

Bear was the biggest and most confident character in his litter, and he very quickly made himself at home with the other animals. Bear loves to boss the dog around, go on adventures at his seaside home and hang out with his mum. He lives the good life.

Pepper

Pepper is a cat of undiscerning tastes.
Don't leave anything made of paper
in his path, or he'll eat it—bills, kids'
drawings, certificates and homework.
Same goes for anything even remotely
edible that you're silly enough to leave
out on the floor or bench. If Pepper
can put it in his mouth and chew it,
then he can eat it. You've been warned.

Eleanor the Catton

When Eleanor the Catton's owner, Jenna, first saw a picture of her on TradeMe, she was overcome with a strong sense that she had to meet the little white cat. Something just told her that Eleanor was *meant* to be her pet. She decided to visit her the very next day.

However, just as she was getting in the car to begin the hour-long journey north of Auckland to CatsnCare, where Eleanor was being looked after, Jenna received a call to say that Eleanor had been put on hold by someone else. Not to be deterred, and since she'd taken the day off work anyway, Jenna went ahead with her trip. CatsnCare rehomes stray, abandoned and abused cats and kittens throughout the Hibiscus Coast area, so perhaps she'd find another feline friend instead? It was worth a shot—and,

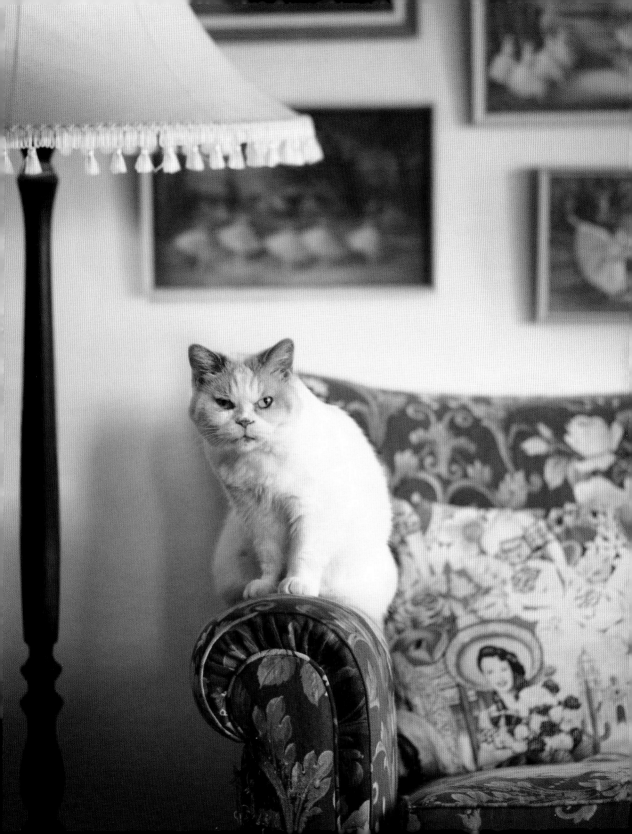

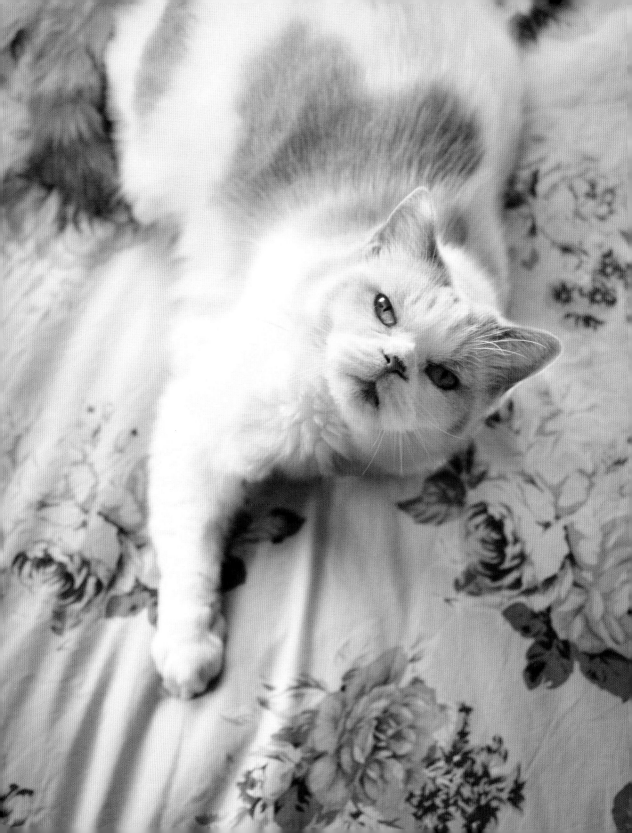

if nothing else, she'd get to spend her impromptu day off getting cat cuddles. Who doesn't like the sound of that?

When she arrived at CatsnCare, Jenna immediately spotted Eleanor through the window. She went inside and spent time meeting the other cats, but none of them was quite right for her. None of them was Eleanor. It seemed the connection went both ways: as soon as she spotted Jenna, Eleanor made a beeline for her and proceeded to smooch affectionately around her legs. Jenna fell completely in love with the little cat. Fortunately, the owner of CatsnCare was there to see it all. It was immediately clear to her, too, that Jenna and Eleanor were destined for each other, so Eleanor went home with Jenna that day.

Jenna manages Time Out Bookstore in Auckland's Mount Eden, and since New Zealand author Eleanor Catton had recently won the prestigious Man Booker Prize for Fiction with her novel *The Luminaries* it seemed only fitting that Eleanor the cat become Eleanor the Catton in tribute. A few days after receiving her full title, Eleanor the Catton was settling into her new home and Jenna happened to take a closer look at the tea-stained markings on her white fur . . . and realised that they matched the design on the cover of *The Luminaries*.

Eleanor the Catton is a tiny fluffball with a resting grumpy face who covers the entire house and all items of clothing in her white fur—but Jenna wouldn't have it any other way.

Fred

Fred the fat chocolate cat is something of a superstar Samaritan. As well as frequently gracing the nation's tellies, he's an outreach therapy pet. For the past four years, he has donated his time to visiting rest homes and hospitals, where he provides companionship, helps to encourage movement in those who are bed-ridden and helps with therapy. Fred is harness-trained, so he recently paired up with one man who needed a walking companion to help him regain mobility after several falls. Fred much prefers this human company to that of the canine variety, which he's sometimes forced to endure at home. (Here he scarpers up and down the handrail on the deck as the dogs run after him.)

During the working week, Fred is a minor celebrity. He's pretty much world famous in New Zealand, and has added the magic cat touch to a number of national adverts. A few years ago, he even earned the honour of becoming the first cat on *Shortland Street*,

playing the part of fierce feline Kronos, who came back to haunt his owner at Halloween. He even had his own papier-mâché stunt double for that particular gig. It was one of his finest performances, if he does say so himself.

This gentleman of many talents also goes by many names: along with the pedigree title of Rosimorn Yabbadabbadoo, he answers to Mate, Boo Boo and Dude. He'll also, like any good actor, perform on command: he will come, sit, stay, shake paws, give high-fives, spin in circles, come to heel, walk through a hoop, and—if it really comes to it—beg. He resides with his personal assistant (ahem, his owner), and he takes his professional development seriously. When the job calls for it, he'll head off for overnight stays with his talent agent to attend training camps or work on location. The show must always go on.

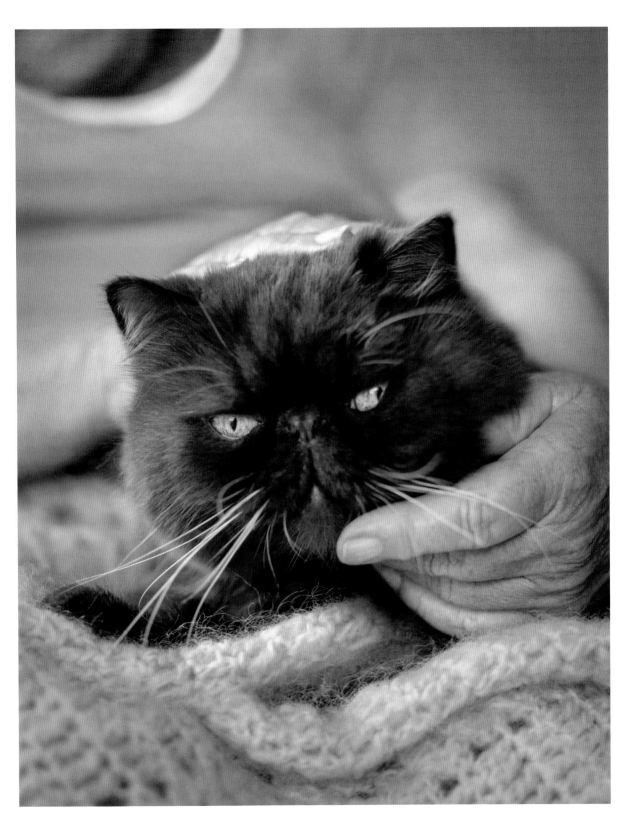

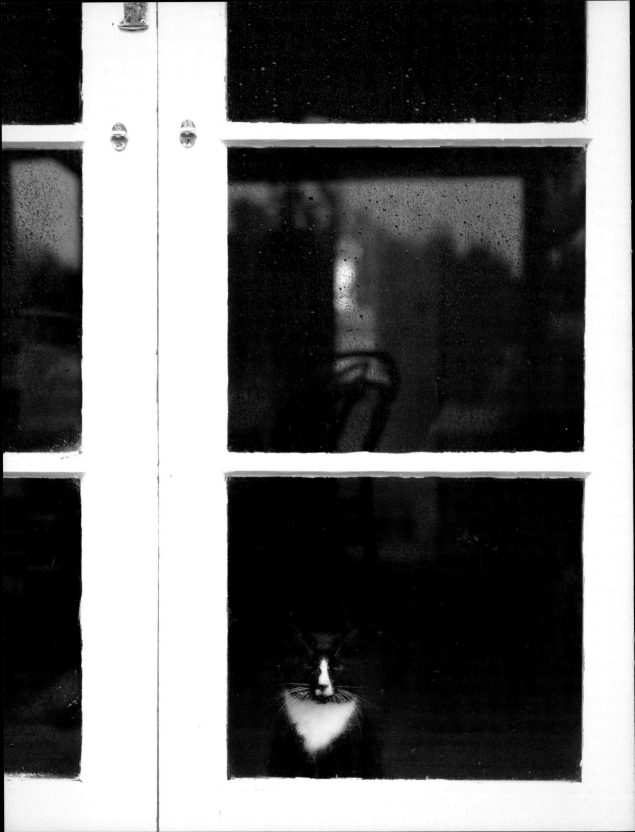

Hunter

Like a character from a Dickens novel, Hunter is a cat who lives up to his moniker. He brings home all manner of 'gifts' for his family, including rabbits, mice and rats. He fancies himself a bit of a nomad, spending long days wandering the farmland near his home, but he's never so far away that he's out of earshot of the call 'Dinnertime!'

Laurie
and Jungle

The team at rescue organisation HUHA (Helping You Help Animals) was dealing with the final throes of kitten season—for weeks, there had been a constant flow of orphaned litters who needed to be desexed, weaned, bottlefed and rehomed—when a scrappy little wild kitten that had been found behind a supermarket was dropped off. The little tabby was only about five or six weeks old, and was quite sweet really, but in her short time had already begun to develop wary street smarts; she scorned human interaction, but, as she hissed and spat at the team, it was impossible not to admire how robust and confident she was.

The team decided that their best bet was to put the kitten in a dog crate in the office, so that she could get used to people and movement (a technique known as 'flooding', where you flood an animal with stimuli to help them get used to a busy environment).

As one of the team members was leaning in to the crate to stroke the little cat, the team leader was struck by an idea.

'Change of plan,' she said. 'Let's try her with Laurie.'

Everyone else looked both surprised and horrified. 'Are you serious?' they chorused.

'Yep, I am,' the team leader replied. 'I reckon she's just what he needs. And I think he might be the best thing to happen to her, too.'

It had only been a few months earlier that the team had finally managed to remove the collar and chain that had been such a harsh reminder of monkey Laurie's life before he'd come to them. But, while to the HUHA team this felt like a huge success—a step on the road to freedom, quite literally, from his former shackles— Laurie didn't feel that way at all.

Laurie had once been a circus animal, and his four canine teeth had been filed down a decade or so earlier, leaving them blunt and with the nerves exposed. He'd

recently developed bilateral abscesses under his chin, and needed urgent surgery under general anaesthetic to get all of his canines removed. The HUHA team had taken this as the perfect opportunity to also remove his collar and chain.

When Laurie awoke, they expected him to feel confused and maybe even slightly violated about the loss of his teeth. What they didn't expect was just how distraught he would be about the removal of his chain. He was a total mess. He would scurry away from anyone who tried to approach, and sit, rocking back and forth and screaming. He wanted to trust the humans, but no longer felt he could. They'd taken his chain.

It was deeply upsetting, not least because up until that point Laurie had gained so much confidence since arriving at HUHA. The team now realised just what a crucial part of that confidence his chain had played: it had allowed him to retain some sense of being in control. When he had wanted to interact with people, he would pass them his chain—and, in particular, he'd pass the chain to Jim, his favourite person. If he had wanted to be left alone, he would guard his chain with crossed arms, chattering nervously. Without his chain, Laurie had lost his routine, his system, his control, his method of communication. He was a wreck. And, to make matters worse, he blamed Jim. Before, they'd had something of a bromance going on, but now he wouldn't let Jim near him.

He clearly felt deeply betrayed.

Laurie had remained inconsolable ever since. He was living full-time in a new enclosure, where he had trees and forts and ropes and swings, but, as far as social

contact went, the humans around him just delivered his food; if they tried to engage with him any more than that, he would slip into a panicked rage, frantically crossing his arms across his bare chest, where his stolen chain had once rested.

Fortunately, the team knew from vast experience that the key with any animal is patience. They reassured themselves that Laurie was safe, he was loved, he was more enriched than he had probably ever been in his sad and lonely life. Although he was confused and hurt, he would heal with time and eventually start to interact with people again.

That was where the feisty little tabby kitten stepped in.

The team already knew that Laurie was gentle with other animals, as he lived happily with two giant Flemish bunnies called Jelly and Bean, who seemed completely unaware that having a monkey as a flatmate might not be the most normal situation for bunnies like them.

What if, HUHA's team leader wondered, *the kitten could be a special creature in Laurie's life? Perhaps it's just what Laurie needs to help him on the road to recovery?*

So, together, she and Jim introduced Laurie to the kitten. As soon as Laurie saw the kitten, he started to chatter and rock, holding his arms firmly crossed against his chest. He was nervous—but it was clear that he was also interested. Almost immediately the bossy little kitten jumped off the team leader's knee; she had zero interest in people and couldn't get herself away fast enough. Laurie inched closer to her, still chattering and swaying as he always did when feeling out of his depth and out of control. Bold as brass, the kitten walked right over to Laurie and headbutted him gently on the leg.

Laurie stopped rocking with a start, as if he'd been slapped in the face.

He focused properly on the little kitten. Gingerly, he reached out and touched her back with one pointed finger, ET-style.

'Awwwww,' he said, as the kitten continued to nudge him and rub up against him. 'Awwwww.'

The kitten started to purr.

Jim and the rest of the team, watching quietly, just smiled at each other.

It took them mere minutes to settle on a name for the kitten.

'I know Laurie will never have a normal life,' the team leader said, 'but I just like the idea of him having a Jungle.'

These days Jungle and Laurie are a tight twosome: they eat together, sleep together, play and hunt together. They groom and sunbathe together. And the more their relationship has grown, the more they have both relaxed around people. As Jungle matured, she was allowed in and out of Laurie's enclosure. She's never caged in, but her place of choice remains with her best friend, Laurie.

The little social experiment worked. Laurie has his Jungle, and she has her Laurie.

Simba

At an impressive fifteen years of age, Simba is a stately older gentleman. Two years ago, his owners noticed he'd lost a lot of weight—very unusual for the normally robust Simba—and when they took him to the vets they learned that he'd developed diabetes. He requires insulin injections twice a day, and is even more adoring of attention and affection than he was before his diagnosis. As a result of his diabetes, he is prone to fits and seizures. When he was first diagnosed, he would have extremely violent attacks and look absolutely terrified. It was very scary and upsetting for his family. Happily, this doesn't happen often anymore, as his humans have got better at recognising the warning signs and making sure he has some food (which he loves) and some glucose syrup (which he hates).

Simba first joined his human family along with his sister Nala, but the two weren't exactly what you'd call 'mates'. For their first few years together, Simba would relentlessly niggle Nala: he'd eat all her food (which explained the disparity in their body size), then proceed to stalk her until she lost control and attacked him. Sometimes he would simply stare at her intently, just trying to get a reaction. So, not that unlike many other sibling relationships, then. Over time, the two managed to carve out a sort of uneasy

cohabitation. Sadly, when both cats were fourteen, Nala shot out across the road in pursuit of a rabbit and was hit and tragically killed by a car, leaving Simba without a target for his pestering.

When Simba's main human squeeze disappeared to go to university in Dunedin, he couldn't work out why she'd left him. He sits in her bedroom, hoping somebody—*anybody*—will come and hang out with him and give him cuddles. Whenever she comes home to visit, he spends about twenty hours asleep in her bed, and she'll wake up in the morning with him wrapped around her neck. He's also worked out that sometimes she appears on this weird, glass-screened thing (is it 'a laptop' that the humans call it?) and he can hear her responding to the other humans talking. He's taken to sitting in the same room when this happens, just so that he can hear her voice—even if he can't quite work out where it's coming from.

For a little lion, Simba is very quiet, but he is incredibly smoochy and good-tempered. He's not much of an outdoors guy; he far prefers the comforts of the interior life. His family used to try to make him go outside to get 'fresh air' and 'some exercise' but he wasn't into that at all. On more than one occasion, he has cracked the locked cat door in his desperate attempts to come crashing back inside.

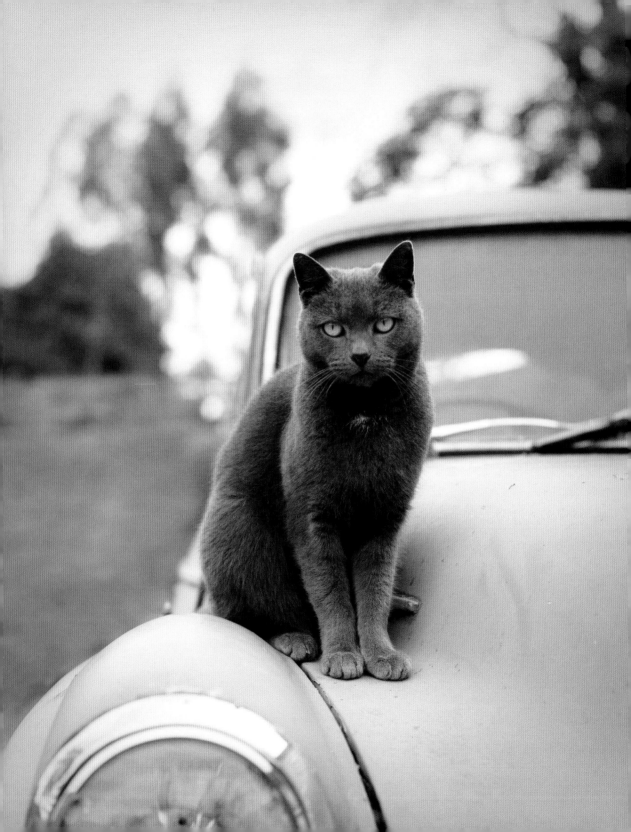

Bloo

Bloo has an independent, inquisitive spirit. If she wants a smooch, she'll let you know, but otherwise she'd like to be left to her own adventures, thanks. Like her owner's husband, she's got a bit of a thing for vintage cars, but she's more interested in napping in them than tinkering with them. Whenever she gets the chance, she'll curl up in the driver's seat of any one of the various retro cars or old-school buses in various states of repair in the workshop.

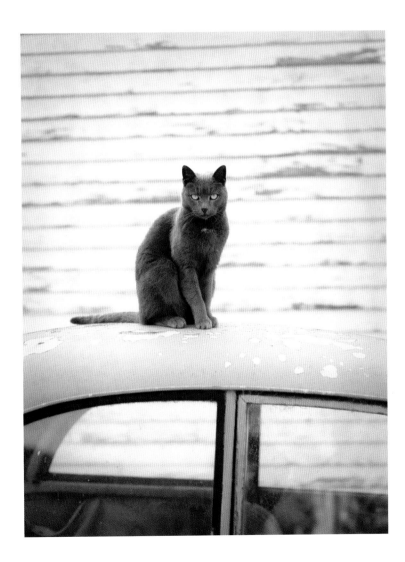

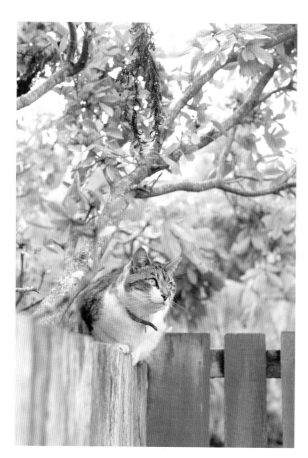

Lily

Lily is a lover of high places, and when she was a kitten she spent most of her time perched on her owner's shoulder, giving the occasional lick on the neck to keep her motivated while she worked. Lily is a social wee creature, and her best mate is Bond the Schnoodle (a schnauzer–poodle cross).

Within three weeks of Bond arriving in Lily's life, she had put the dog firmly in his place with a swift swipe to the face. Ever since, Bond has treated Lily as the goddess she knows she is, and he is always careful to offer her due reverence. Lily will weave in and out under Bond's tummy, then offer her ears up to him . . . so he can lick them clean for her. A lady *never* cleans her own ears (or so Lily would have Bond believe).

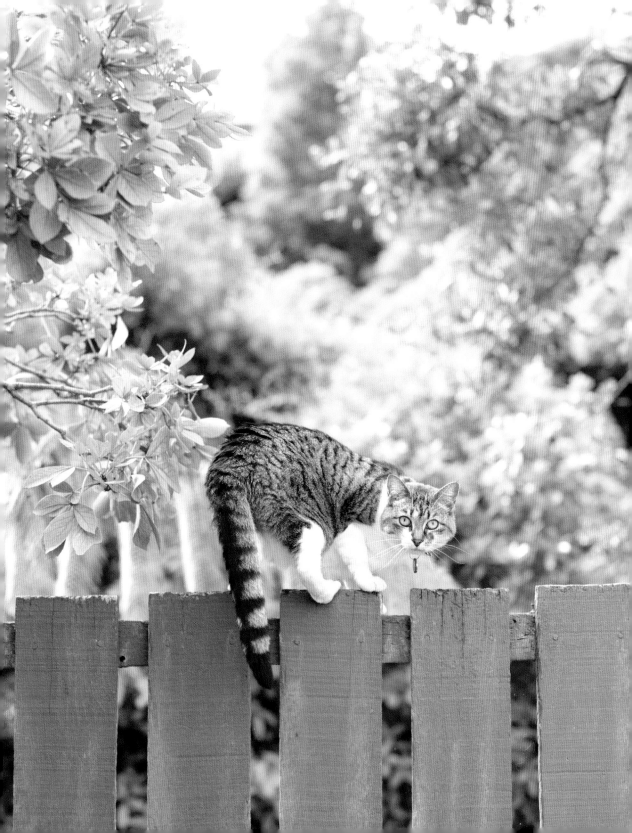

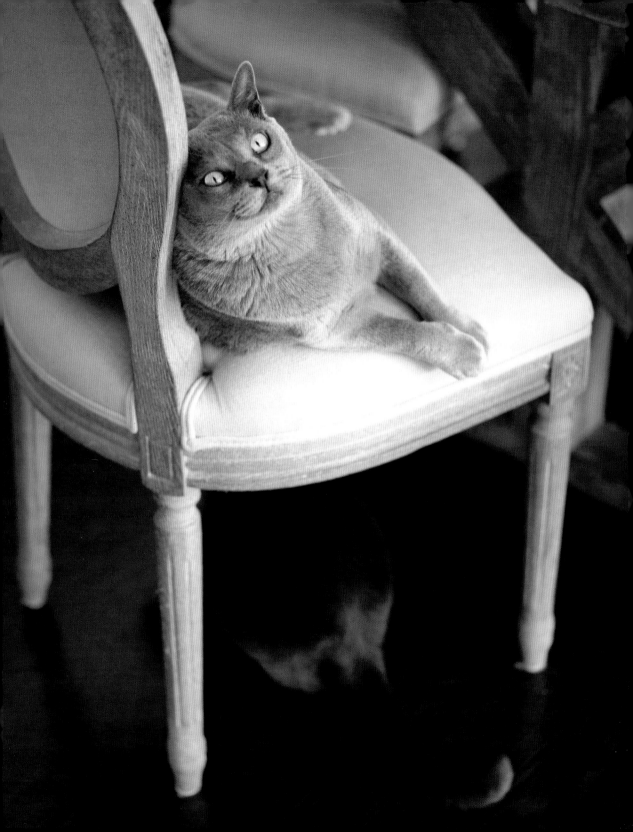

Merlin, Mini, Cougar and Knight

This foursome of beautiful Burmese cats form a rather lovely pastel collection— Knight is the cream one, Merlin the blue, Mini the lilac and Cougar the chocolate. Their owner claims it is pure coincidence that they happen to go quite so well with her décor, and promises she didn't design her interiors to match her cats. (Well, maybe she did, just the tiniest bit . . .)

The cats seem very happy about their surroundings; anything that contributes to their already photogenic faces is fine by them! They know how good-looking they are, and have no qualms whatsoever about flaunting their beauty when a camera is pointed at them.

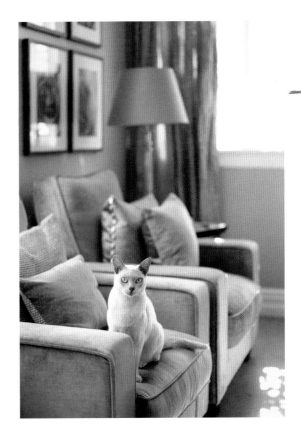

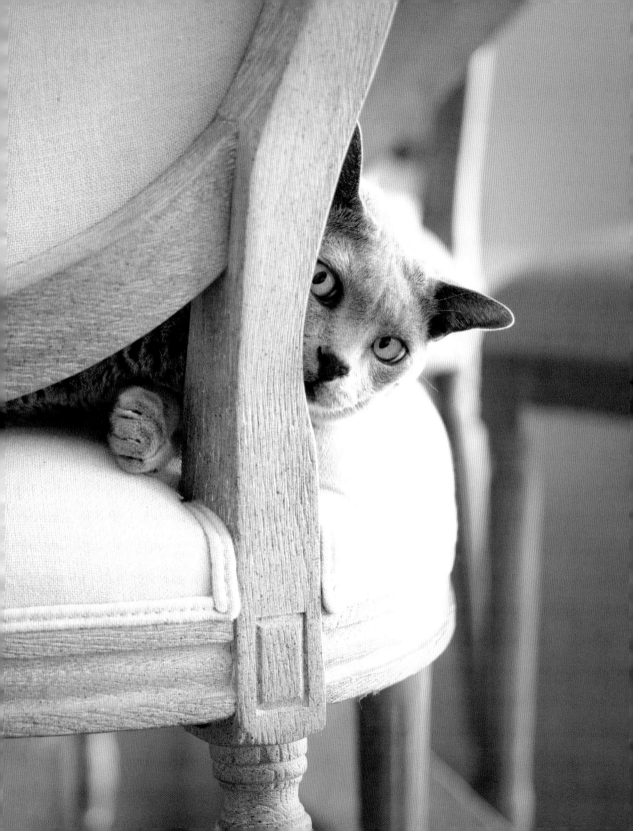

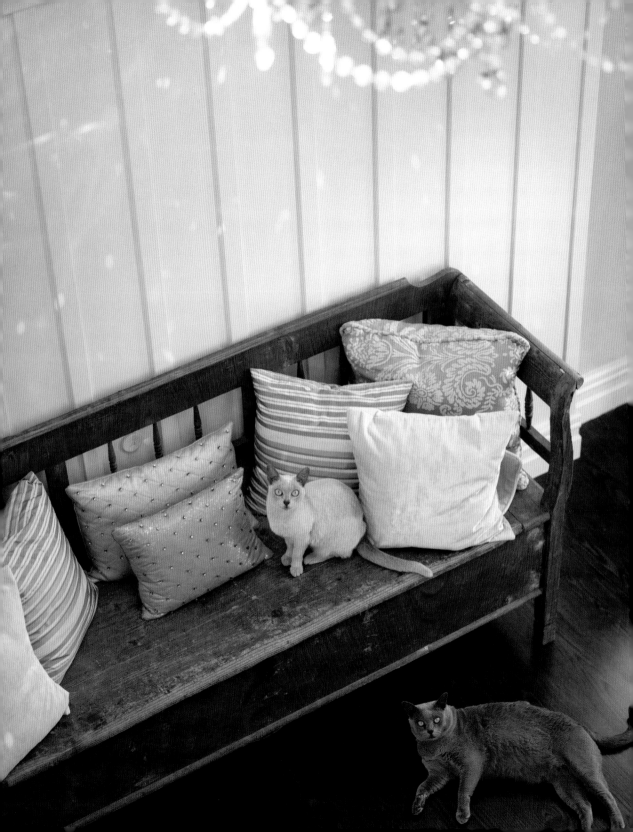

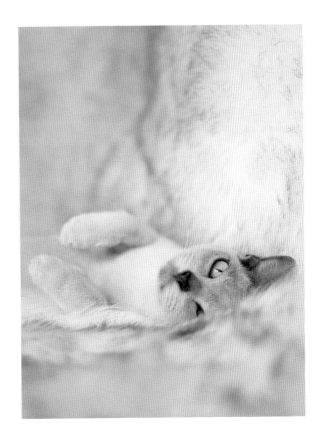

Mini is the biggest poser of the lot. The moment she sniffs a photo opp, she gets into position, knowing instinctively how to arrange herself so as to show off her best angle.

Merlin is the cuddler of the bunch, always ready to seduce an unwitting human into showering him with love and affection.

Cougar, on the other hand, makes you work harder for her attention. She has that haughty knack so particular to cats of being friendly enough—while never letting you forget how grateful you should be that she's giving you some of her precious time.

Knight is a welcoming soul who especially enjoys hunting. His green eyes pop startlingly out against his pale fur.

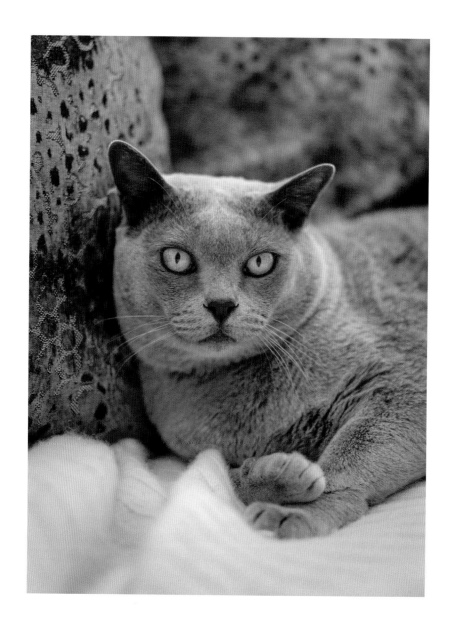

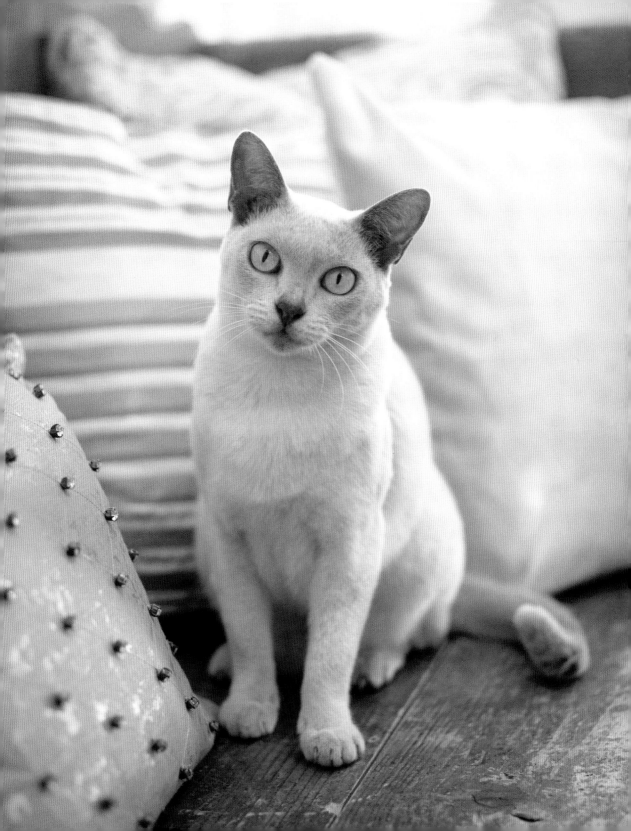

Tiger

At only three years old, Tiger had lived a short but very sad life. He'd been badly abused at his previous home and was in extremely poor condition, very thin and full of worms when he came to his new owner. Many people chipped in to help to bring him back to health, but it was a slow and painful process, as he couldn't keep any food down and he hadn't been fed for a long time.

Happily, Tiger's story took a turn for the better and he's now fully recovered. This sweet and loving boy has a happy life with his owner and his other feline companion, Cocopops. He's playful and affectionate, and the neglect of his past is firmly behind him.

Sweetypie
and Star

Sweetypie and Star are flatmates. They share the same enclosure (their owner lives on a very busy main road, so it keeps them safe that way), and they are each as cheeky and enterprising as the other. They're both rescue cats who made their way to their owner through completely different circumstances.

Sweetypie (overleaf), who is deaf, was dumped at the age of two at Christchurch airport, and found by a woman out walking her dog, who thankfully took her to Cat Care, a cat-rescue organisation in Rangiora. Cat Care then advertised Sweetypie as available for adoption in the Sunday paper, and that's how Sweetypie's owner found her.

Don't be fooled by how pretty Sweetypie is, though; she is definitely not a lap cat. A feline Houdini would be more like it. She's a free spirit and will stop at nothing to make a sneaky escape from her enclosure. Luckily, Sweetypie can't resist the allure of a flitting red laser light, so it's never too much trouble to lure her back to safety. Her owner communicates with her using a kind of sign language that the two of them have come to agree upon.

Star (left) is a Turkish van cat who came to her owner's home in Christchurch from a Sydney pound. On the day that two-month-old Star was to be put to sleep (no one had claimed her), her new owner adopted her and made the arrangements for her to come to New Zealand on an aeroplane. Star was completely unfazed by the journey, and settled right into her new home. This strong-willed pedigree is a very outgoing girl who was just a tiny bit naughty when she was a kitten. She'd chew through ear plugs and cords, unravel toilet-paper rolls and leave them strewn everywhere, and once got into a big bag of kitty litter and spilled it all over the floor— then played in it for a while before doing a poop in it (at least she's tidy, right?).

George

On their first Valentine's Day together, the husband of George's owner gave his beloved the best gift *ever*: George the kitten. This fluffy lad was a trusty sidekick, and often accompanied his owner to work when she did night shifts at the local police station. George was more than happy to provide the entertainment to help everyone to pass the long nights. The staff would scrunch bits of paper up into balls and toss them down the long (and highly polished) hallway, then George would shoot off in hot pursuit—but he always ended up losing his footing and skidding along the floor until he was brought to an abrupt stop by the wall at the end of the corridor. Still, no matter how many times he hit the wall, he couldn't give up on chasing those balls of paper.

When morning came, George's owner would let him know it was time to head home by rattling a paper bag. He'd obediently trot over to her, hop inside the bag and wait to be carried out to the car.

Ever alert to opportunity, George soon taught his owner's young daughter where his cat treats were kept. He'd gently headbutt her, as if to say, 'How about one of those yummy lolly things, then?' and lead her to the cupboard where they were kept. (There's a strong suspicion that it was George who taught her how to open cupboards in the first place.) It was difficult to be mad at him . . . until he started waking her up at four in the morning to get at his treats. Unfortunately, no one could shut her bedroom door, as George would scratch at it until someone opened it for him, so he continued to get his treats whenever he desired them.

Skinny

With her extremely soft grey fur and cunning personality, Skinny makes for the perfect household cat. Her daily life on the farm is one of bliss: hunting, joining her humans for a wander, helping them catch the horses, or lending a paw in the workshop. If no one is around, you will find her fast asleep somewhere in the house.

Someone usually gets woken up in the middle of the night to tend to Skinny's demands, and she's developed a number of tricks for getting the attention she requires. One of her favourites is to climb along the top of the headboard then jump down on the chest of whoever is sleeping below; this is a pretty fail-safe way to get them to wake up and let her outside. When she wants to come back inside again, she'll choose a windowsill with a sleeping human on the other side and meow loudly until she gets let in.

Rosie
and Yoey

When Yoey's family went to collect their new kitten they were initially a little disappointed. He wasn't anywhere near as fluffy as he'd looked in the pictures in the ad. But, as soon as they cuddled him and saw how cruisy he was, they knew he'd be a perfect fit for their family. He explored their car thoroughly on the half-hour drive home, and by the time they arrived was a firmly entrenched family member.

This mellow tabby has become a real farm cat and quite the hunter, and he loves nothing more than following the kids around their property. He'll walk along the tops of the kiwifruit vines, keeping an eye on the children, and chase after them when they trail broken branches for him. He's very protective of them, and sleeps in their rooms with them at night.

Rosie was the family's dreamed-of fluffy cat, and was sadly only with them for a year before she was hit by a car. In her short time, she was an adoring and adored part of the family, always up for a cuddle. She and Yoey—who's also called Yoyo— were very good friends and would sleep curled up together in a big fluffy ball. She's dearly missed, and now was laid to rest in the rose garden, where the kids can visit her grave often.

Buttons

Buttons is a kleptomaniac. She can't help
herself: she loves to steal washing, and as
a result of her compulsively sticky-pawed
pursuits has earned herself the nickname
Slinky Malinki. Her owners came home
from work to find upwards of a dozen items
of pilfered clothing waiting for them: socks
and undies, slippers, T-shirts and bras. Once
Buttons even managed to find a swimming
cap and carry that home.

 When her family welcomed a new baby,
Buttons took it upon herself to provide
for him in her own way, bringing home
baby socks that she'd leave next to his toys.
One day she even managed to find him a
swimming diaper (that was a particularly
successful day).

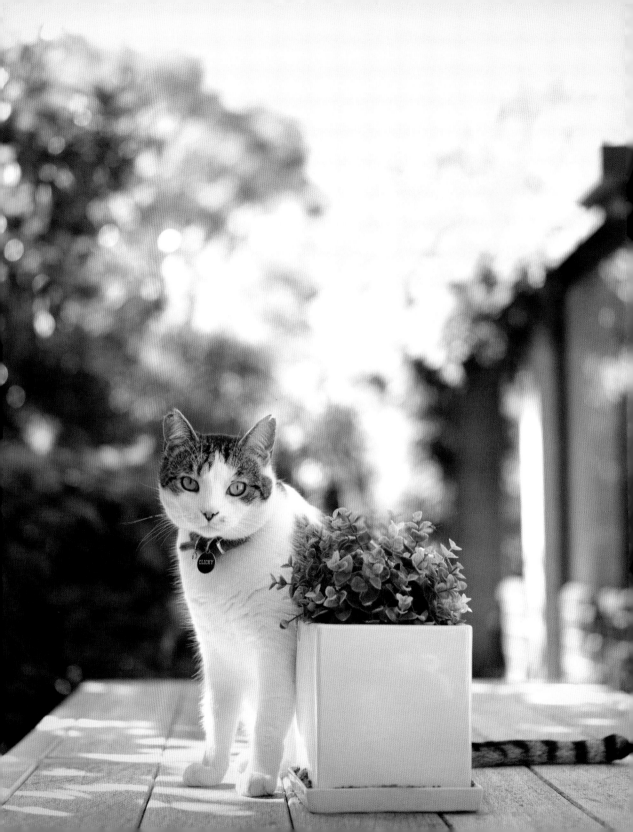

Clicky

Clicky's owners found him four years ago, cowering in their Christchurch garden with a broken ClickClack-container lid stuck around his neck. He was utterly terrified and no one could get close to him, though they left food in the shed for him. However, a couple of weeks passed and it was clear that Clicky's condition was deteriorating, so his caregivers called in Cat Help, a charitable trust committed to cat welfare, to help catch him. They managed to lure him into a cage using food, and rushed him straight to the vet, where the container lid was finally removed.

Although he was a stray tomcat—the vet reckoned he was about eighteen months old—he was very placid about the whole affair. His now pristine coat was yellow and rough, his ears torn and he smelled terrible, but he was very friendly once he realised that the people around him meant him no harm. The vet flea-treated, bathed and neutered him, and his caregivers decided to bring him home to be part of the family.

Clicky instantly showed his gratitude for the chance they took on him by way of affection, and before long his loving personality emerged. Now, Clicky always stays close to home, seeking out the company of one of his human family members. He invites himself to join in on afternoon teas with visitors, board games and family meals. In fact, when it comes to food, Clicky can't really say no; he's a bit of a glutton. He's obviously never forgotten his days as a stray and nothing even remotely edible is safe from him—he'll happily clean up an unwatched bowl of Weet-Bix or crunch his way through your toast while your back's turned.

When the family expanded to include a Schnauzer puppy, Clicky welcomed her with his characteristic good nature (despite the occasional puppy nips and chasing). The two are great mates and often play together. He's a far cry from the petrified moggie who appeared in the garden all those years ago.

Lynx

Well, hello there. My name is Lynx. They tried to write about me on my behalf in this book, but I wasn't having any of that nonsense. I'd prefer to tell you my story myself, thank you very much. Some cats might not have the—how shall I put it?—*intelligence* to tell their own tale, but I'm quite up to the task (and more so than any mere human).

So, where shall I begin?

At the tender young age of thirteen weeks old, I was snatched from the cosy litter of my kittenhood to be adopted by a lady called Catherine. Fortunately, this Catherine turned out to be a woman of good sense (though, of course, I had an inkling of that already, since she had chosen *me*) and gave me the appropriately reverential name of Lynx. I understand this was due to my refined and genteel appearance: my pointed ears, my chiselled jaw, my slender ankles. I am a cat of good breeding.

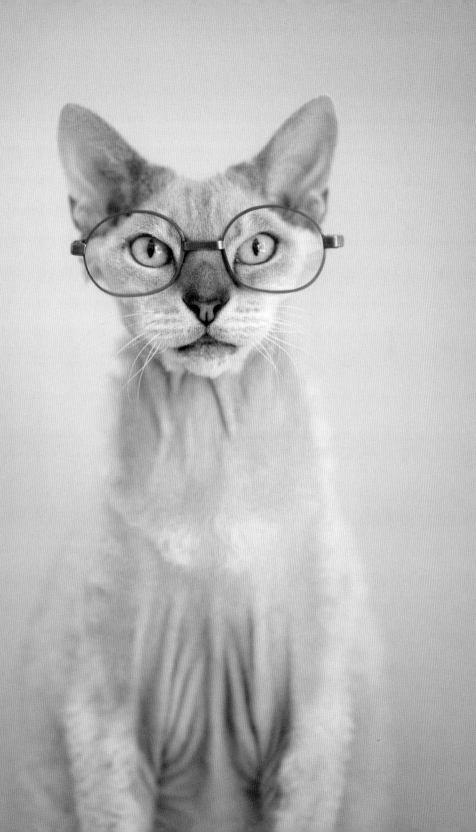

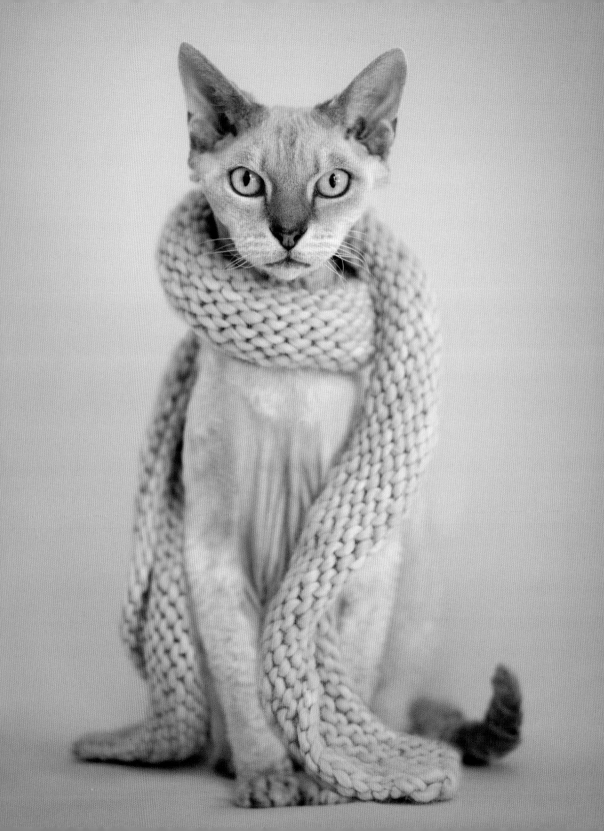

My life with Catherine has been one of travel and adventure. We have visited all corners of the earth, meandering aimlessly together along sandy beaches, driving through lush countryside, and absorbing all the colours and vibrancy of exotic locales near and far. My travels are always punctuated by regular naps (one must take care of one's complexion, and they say that nothing leads to wrinkles like fatigue), and filled with ever-intriguing observations of people of all shapes and sizes, other creatures—dogs and chickens are my favourites—vehicles and new smells. I have met with many an adoring fan—I'm a particular hit with the ladies (though I gather that will come as no surprise to you).

I have heard tell that others of my feline brethren are wont to scrap and fight, and to catch mice. I cannot imagine anything worse than bickering lamely over such a pithy thing as territory, and as for rodents? Disgusting! Not for me at all. I'll leave *that* to the commoners.

Catherine is very lucky to have such a sophisticated and noble companion as *moi*, and I do not doubt that her life would be significantly inferior without me by her side. For now we call the South Island of New Zealand home, and I am learning what it means to be a true Kiwi cat.

Pudding, Huckleberry and Milly

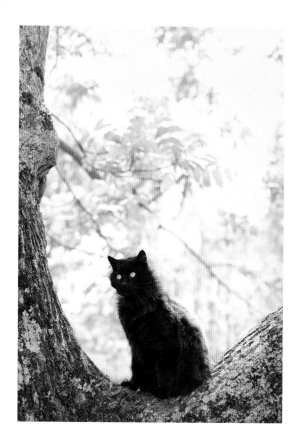

Deep in the heart of the Pongakawa forest, just under an hour's drive south-east of Tauranga, lies a collection of picturesque historic school buildings that were built in the 1930s then disestablished as a school during the 1980s. In more recent times, the school buildings have gained a new lease of life as an utterly Instagram-worthy vintage wedding venue—and we all know that Instagram loves nothing as much as it loves weddings and cats.

Pudding (left) is the first of the Old Forest School feline trio. He chose his humans at the SPCA all of twelve years ago. His family had gone with the intention of getting a kitten, but six-month-old Pudding made it abundantly clear to them that he was the cat they should take home . . . He climbed

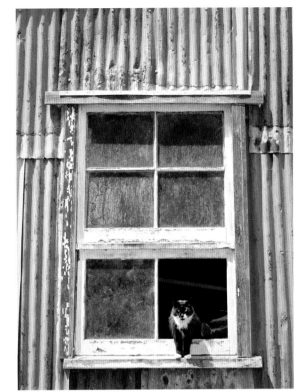

up on their shoulders, made himself comfortable, and the rest is history.

Pudding is a very chatty fellow, although often all that comes out of his mouth is a weird kind of squeak. He purrs like rolling thunder and dribbles like a stream. He loves sleeping on the school's hot asphalt tennis court during summer, and in winter he can reliably be found curled up outside in the rain. Yep, you read that right— outside. In the rain. In summer, you can set your clock by his hunting: he knows exactly when the bunnies are due to leave their burrows in the morning and at night, and will patiently wait for them. He's always successful, and always brings his hunt home to share it with the other cats.

Huckleberry (right) came to the Old Forest School family via a neighbour, who had seen him at the vet; someone had captured this feral kitten and taken him to the vet in the hope that someone might adopt him. You'd never know his troubled beginnings now, as he's the most chilled-out, smoochy boy.

Huckleberry is a simple boy, in a Forrest Gump sort of way: he is always knocking stuff over, forgetting which door the cat door is in, falling off wherever he is sleeping. He has a white ballet slipper on one foot—most likely he lost the other one. Unlike his brother, he's not a hunter at all: he loves his biscuits, and only his biscuits— no tasty tidbits for him, or snippets of cheese, thank you. Just the biscuits.

Milly (page 83) was found at a pet shop— not usually the place where her family

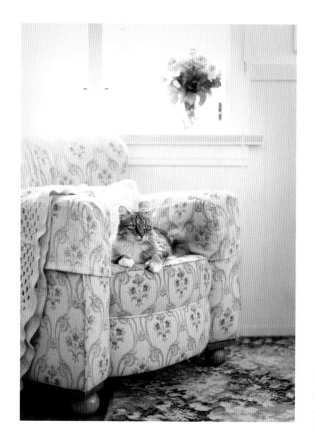

would look for a pet, but she was so tiny
and looked so, so sad that it was impossible
not to take her home. As it turned out, she
was too tiny: she was too little to have been
taken away from her mum, and she was
sick. Really sick. The vet advised her family
that it would be kindest to put her down,
but they wanted to give her a chance at life,
so they set to work, helping her to grown
healthy and strong.

Now Milly is quite the stunner. People
often think she has Norwegian forest cat in
her, and she certainly looks the part. Her
crazy-long whiskers are only one inch off
the world record. Milly loves people, and
is often on the prowl for a warm lap and
a friendly pat. Always the lady, she refuses
point blank to use the cat door, preferring
that someone open the window or the door
for her.

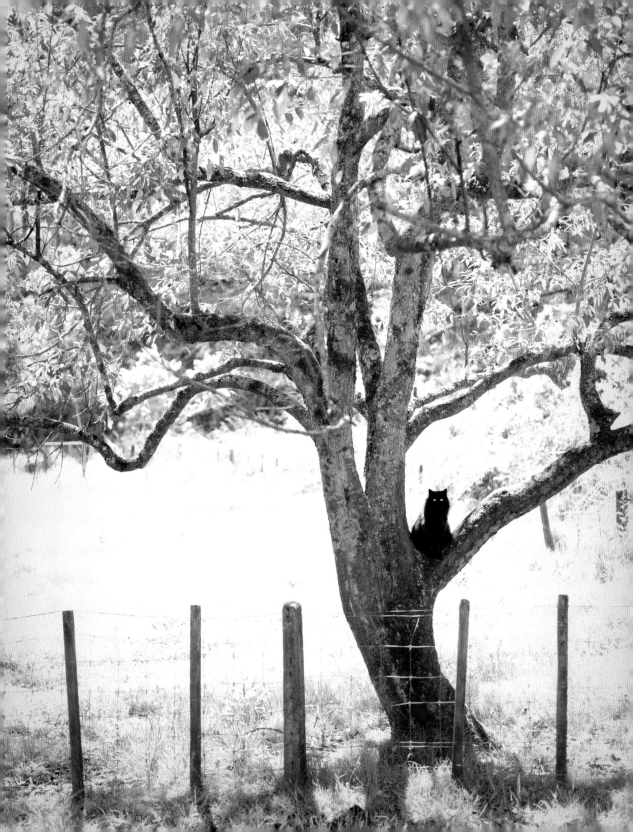

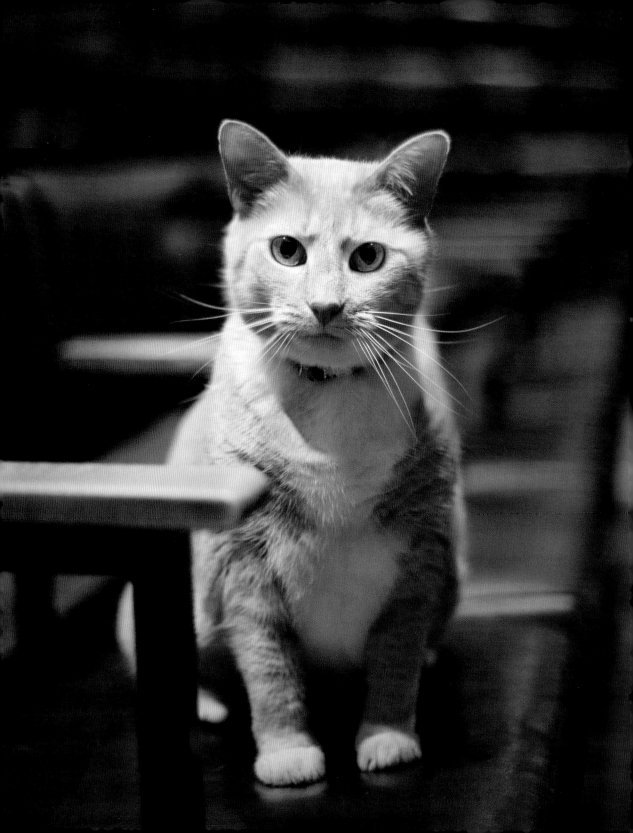

Poppy

Several years ago, Poppy was rescued from abusive owners and taken in by the SPCA. When Bill, the human who would adopt her, first met her it took a good fifteen minutes before she would allow him to even pat her. She went home with him, and spent a week hiding under the bed.

When she eventually came out, though, she realised just how improved her new circumstances were: Bill is the manager of the theatre at Auckland Grammar School, and Poppy soon realised that she could follow him to work every day. The theatre proved an ever-intriguing adventure land, and Poppy was soon appointed to official Theatre Cat duties. Bill likes to tell visitors to the theatre that Poppy is really the manager; he just carries her keys (she's got

no thumbs, so she needs someone to open the doors for her, you see).

Poppy likes to watch rehearsals from the prompt aisle, but she always knows when it's a performance night and will make her way to the entry foyer, where she greets the audience and elicits pats and cuddles. She's also made a bit of a habit of joining the headmaster or other guest speakers on the stage—someone's got to oversee proceedings!

At one of the first dance competitions she attended, Poppy found the perfect spot to curl up and go to sleep: on an empty seat at the judge's table. In the middle of the under-eights' performances, she woke up, but nobody noticed, so she reached out and tapped the judge's bare knee. The judge screamed—a furry paw prodding her leg was the last thing she was expecting! (Fortunately, the judge loved cats and the dancer on stage at the time wasn't too traumatised by being screamed at in the middle of her dance.)

In her early years at the theatre, Poppy was quite a hunter. She'd clear out rats' nests and even bring in the odd pigeon, but in summer her favourite toy was large brown cockroaches. Sometimes she'd collect up to twenty in one evening, and for several summers Bill's morning routine included sweeping up Poppy's 'toys'.

Sooty

Cheeky Sooty might have had another life as a pirate's cat: not only does she love water, often joining her small owners in the bath or the paddling pool, but her preferred mode of transport is perched on a shoulder like a parrot. From there, she can survey the world before her, keeping an eye out for the next adventure.

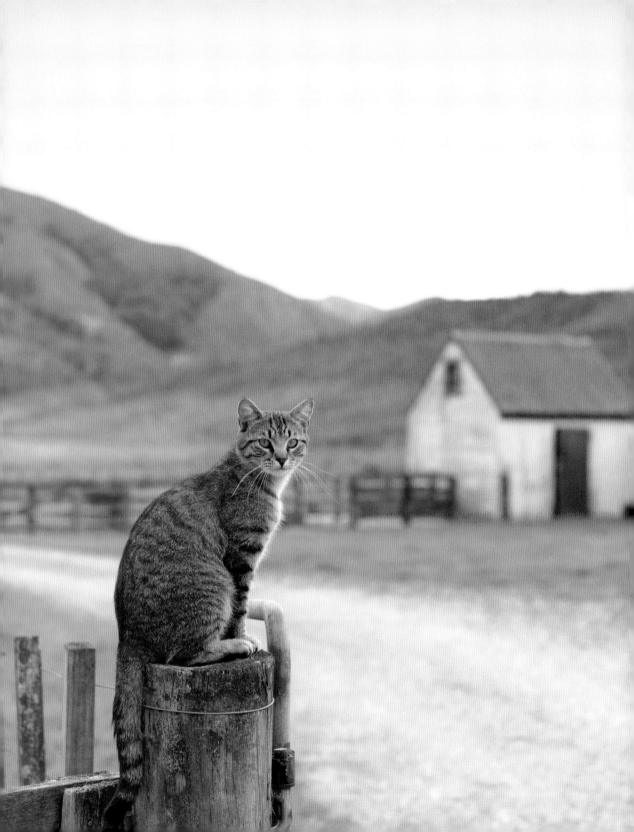

Woody

For some reason, Woody's humans think he's naughty. Who knows why. He's *so* helpful in so many ways—he leaves big fat rats decapitated on the front lawn just for them, he thoughtfully covers every inch of their household with his fur, and he sometimes sets off in visitors' cars for adventures (unbeknownst to the visitors, or his owners, of course).

Woody's best friend is Shylo the dog, and he makes himself cosy curled up with her in 'their' dog bed. He's also mates with Billy the goat, and he can't get enough of tiny humans. They're so cuddly! They squish him and squeeze him and he thinks it's just lovely.

Rosie

Prior to joining her family, British blue Rosie had led a life of confinement, kept in a cage and used as a breeding and show cat. When her reproductive system gave up the ghost and she could no longer have litters, a dire fate awaited her: she would be put to sleep if she couldn't be rehomed.

Fortunately, her new owners decided to welcome her into their family, despite the fact that she'd given them a quick chomp on their first meeting! She did purr a bit, too, so that made up for it—but immediately after that small show of affection, she scooted into hiding behind a sofa.

It took her two years at her new home before she was brave enough to venture outdoors, and even now she'll still come inside to use the litter box (though whether that's a matter of convenience or otherwise is debatable). Despite being a mostly indoors kitty, she's still got some keen hunting skills, especially when it comes to moths. She'll wait till they come out at night, then—making the most of her flat face—she'll suck them right off the windows.

Rosie rules her house with a furry velvet-blue fist, occasionally giving the toddlers a quick biff to keep them in their place. She'll only sleep in her owners' French linen (no polyester for her, thank you) and, built like a concrete block with legs, she stomps around the house keeping an eye on everything.

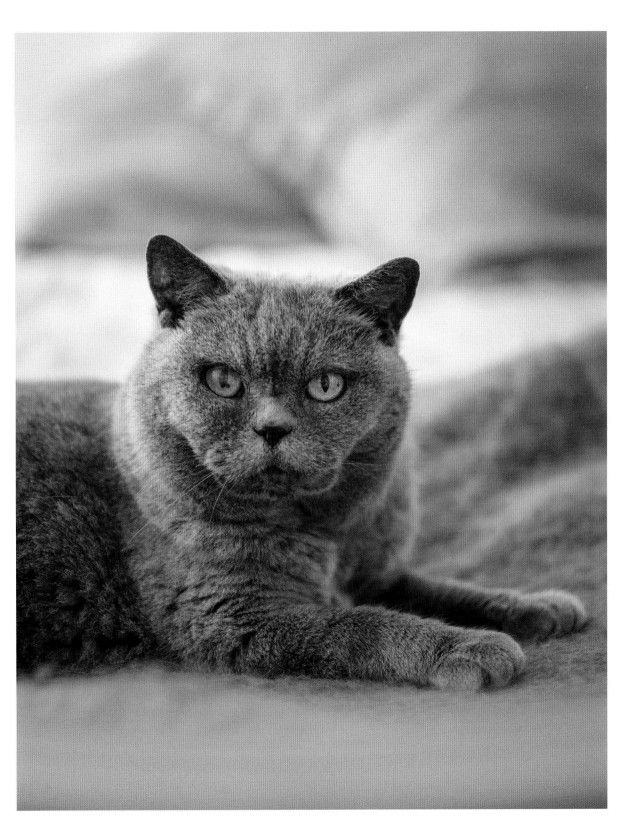

Marty

Late one cold, wet autumn evening, Marty's future owner was driving home when she spotted a four-month-old kitten hunkering down on the side of the road. She pulled over and had barely opened her car door before the kitten had jumped inside and was smothering her with smooches. From that moment on, Marty was officially part of the family—and his enthusiastic snuggling for the remainder of the journey home made it very difficult to keep the car on the road!

Marty had a few 'issues' when he first arrived at his new home, mostly of the pilfering variety. He'd sneak food off the kitchen bench, make off with socks, and be caught chewing on stolen underwear and electrical cords. It was both adorable and rather naughty at the same time, and his antics were met more than once with the (empty) threat of shipping him off to the SPCA if he didn't cut it out. The upshot is that he carved out his own hashtag in the process: #nortymarty.

As he's grown up into a strong, healthy and affectionate four-year-old, he's shed some of his naughtier pastimes. Nowadays he's more of a yoga buff, and he's all about living a chill life. He's very well behaved . . . most of the time. (He only occasionally trashes loo rolls and fights with his toy rabbit these days.)

Chilli

It was love at first sight when Chilli's owner met him: he was twice the size of his litter mates and instantly bombarded her with affection, and hasn't stopped to this day. His full name is actually Red Hot Chilli Pepper (after the band), but that's a bit of a mouthful, so Chilli is just fine for his friends—which is everyone. Every time a visitor arrives at his pad, he'll gleefully greet them and instantly give their lap a go. He adores children, and is always up for some playtime and fun.

When his owner's father was ill, Chilli kept him company, and was a huge source of comfort especially during his final days. Then, when his owner's mother underwent a year of chemotherapy and radiotherapy, Chilli was there by her side the whole way. This wise old soul always has time for everybody, and has a sixth sense for when a cuddle is needed.

Chilli is a Central Otago cat, and it's not uncommon during the winter for him to wake up and find his home blanketed in thick, white, glistening snow. The moment Chilli notices that special glow coming through the windows in the morning, he's outside, gambolling and leaping through the deep powder, completely unfazed by his icy toes. He doesn't need to worry though: there's always a warm fire and a sheepskin rug waiting for him at home.

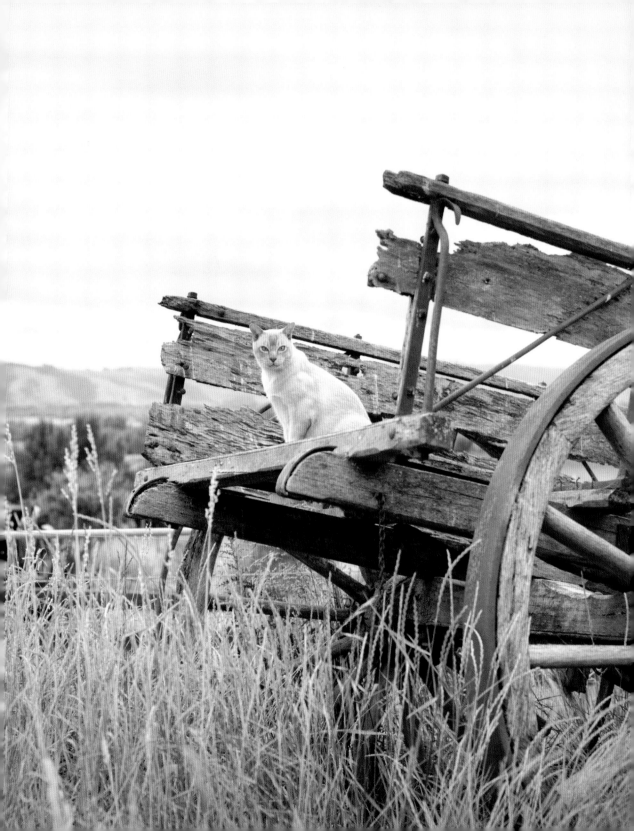

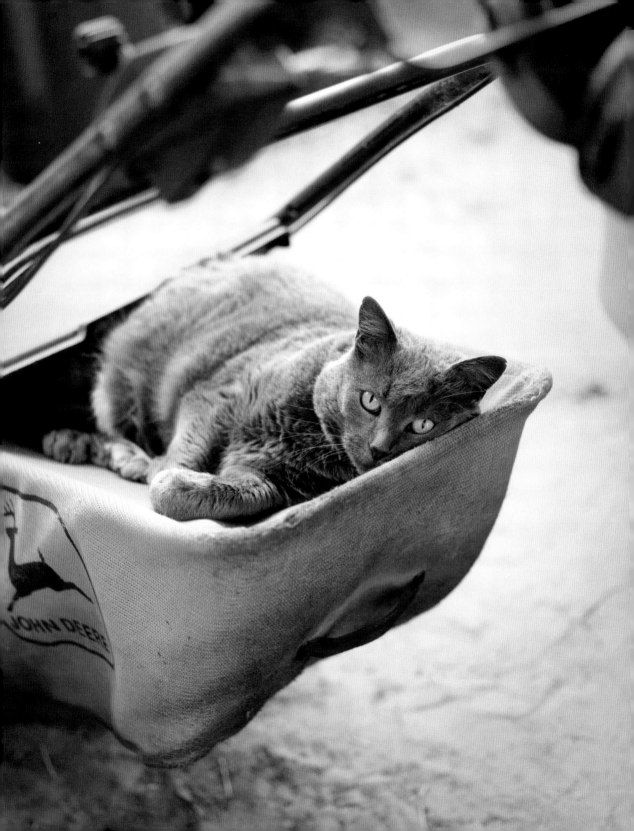

Sooty

When some friends of Sooty's soon-to-be family were adopted by a stray cat whom they named Purry, they found themselves in something of a bind. They were moving out of town, and they couldn't take Purry with them. What were they to do? The only option seemed to be to get Purry put down, but Sooty's family-to-be contained one little human who refused to give up so easily. She couldn't bear to see Purry meet such a dire end, and she pleaded with her parents to take Purry into their already extensive menagerie. They agreed, and Purry came home with them . . . and a few short weeks later, one cat became six! Purry gave birth to a litter of five adorable little kittens, all but one of whom were promptly fostered out to forever homes.

Soon there was just the little runt left, a scraggly little creature with dull grey fur and sharp features. Nobody seemed to want her.

So she stayed right where she was, and was named Sooty.

Sooty became the constant (but not always willing) sidekick of the family's little daughter, suffering a wide array of costume changes from one doll's outfit to the next, spinning rides around the park in a pram, and forced play 'feedings' from a baby doll's bottle. Sooty good-naturedly took all of this in her stride, and the little girl eventually grew into a young woman and set her dolls aside, much to Sooty's relief.

Now in her twilight years, Sooty can be found wherever the day's last ray of sunshine is falling, or curled up on top of the lawnmower grass-catcher, where she soaks up the lingering heat from the engine. Sooty has given her family a lifetime of joy and entertainment, and has thoroughly earned the right to enjoy her wiser years in peace and quiet (without a doll's bootie or bonnet in sight).

Van

Eight-year-old Van would rather hang
out with the dogs than with his fellow
felines. Rather than residing at his human
family's house (where there are other cats
to compete with for attention), he prefers to
make his home at their boarding kennels.
He has even been known to put himself to
bed with the guests—much to the horror of
the unsuspecting dogs!

The kennel customers have come to know
and adore this social and affectionate cat,
and Van will go to shameless lengths to gain
their attention. While they're trying to pay
up and leave, he'll loll about on the front
desk, and it's not uncommon for him to tip
right over the edge and land with a *plonk*
on the floor. On more than one occasion,
a customer and their pooch have tried to
depart, only to discover a furry black-and-
white stowaway in their car.

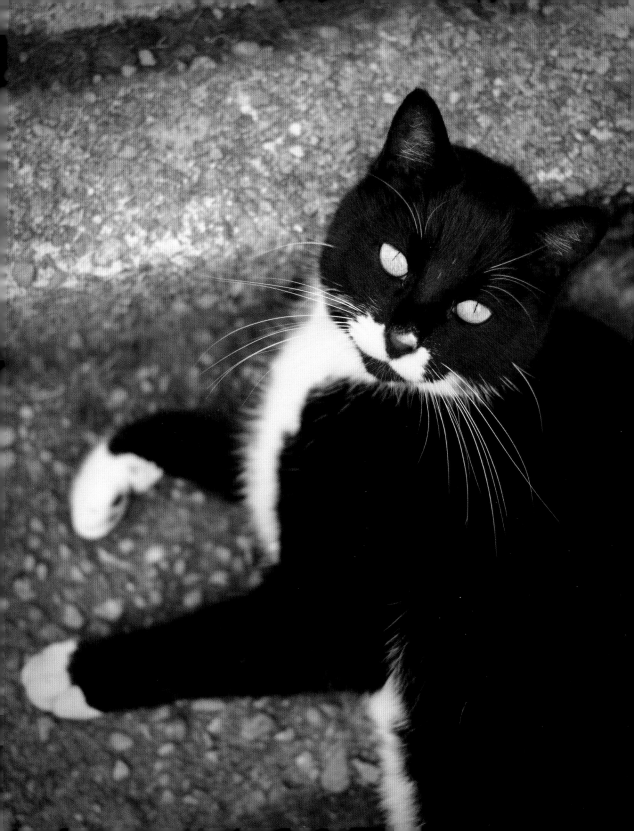

Scarlett
and Murdoch

One day, the team at HUHA received a plea for help from another cat-rescue group that had taken in a stray and her litter. The group's policy was to test stray cats for FIV—a feline version of HIV—and the mother cat had sadly tested positive, so they had euthanised her and wished to rehome her surviving kittens. There was just one problem: three of the kittens appeared to have no eyes!

HUHA agreed to take the blind kittens in, and a quick trip to the vet confirmed that two of them—Columbo and Murdoch, the two boys—were indeed completely without eyeballs. The little girl, Scarlett, however, did have partial sight in one eye. The vet also confirmed that all three kittens carried the FIV virus.

HUHA decided to give the kittens the chance to choose their own future. They would carefully watch them and try to work out what might be best for the little cats' future. Almost immediately it became obvious that the kittens weren't hampered in any way by their lack of sight: they played, purred, stalked and adventured just like any other kittens. As they grew, their other senses became stronger to accommodate their inability to see. In a strange twist, the fact that the kittens were completely or partially blind actually made handling their FIV more manageable. It's not socially responsible to allow a cat carrying FIV to roam freely, for risk of infecting other cats, but this wasn't an issue with these three: since they were unable to see, they couldn't be allowed to roam anyway. They are the perfect indoor apartment cats, full of love and affection and a zest for life.

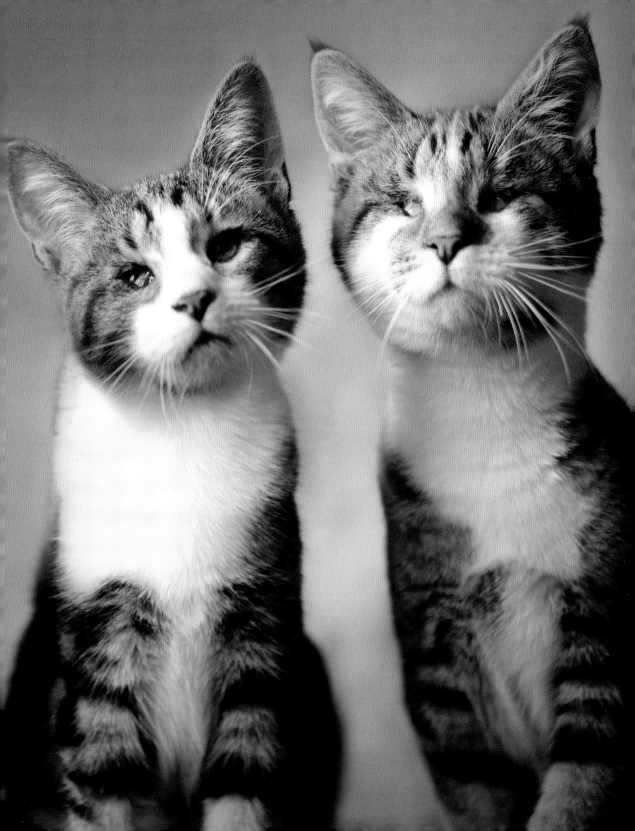

When Storm first came to her family they worried they'd made a terrible mistake. The tiny kitten spent the first few days in her new home hiding under the couch and spitting at anyone who came near her. By day three, however, she'd calmed down enough to venture out into the open—and got straight down to the cuddling. Her family breathed a collective sigh of relief.

This quirky cat would often pop next door to visit the neighbours, and had a knack for appearing if anyone was out in the garden or about to sit down for a cup of tea. If you stayed still for a moment, she'd be up and on your lap, and her signature mode of sitting was to drape her front half across your knees with her bottom half stretched on the couch. She liked enclosed spaces, and was especially fond of wedging herself down into the crack between the cushions on the sofa. If the fruit bowl was left empty, she'd curl up inside it and go to sleep.

Storm

Agnes

When Agnes was discovered lying stiff and unmoving on a Wellington doorstep, the person who found her told the after-hours vet clinic they'd found 'a dying cat'. However, one look from the vet was all it took to confirm that this remarkable yellow-eyed lady was, in fact, very much alive—she was just scared stiff. Literally.

Agnes (pictured here at HUHA with Beanie, a dumped puppy with hydrocephalus, and Walter, a farmed pup and parvovirus survivor) suffers from a unique muscular condition that means that whenever she's worried or startled her body seizes from the end of her tail to the tips of her ears. Even her eyelids and stunted limbs freeze in place. As soon as the threat is gone, Agnes's muscles slowly relax and she returns to her usual gentle pace.

Since this condition seizes Agnes's muscles several times a day, she's unable to run and jump like a normal cat. Even at full speed, she resembles a happy sloth. She's not in any rush, and embraces the world with a Zen much like that of a wise philosopher.

Carolyn, the vet nurse who tended to Agnes the night that she was delivered to the after-hours clinic, initially took her home and tried to find out where she had come from. Surely someone was missing this special cat? It was hard to imagine that she could have survived all on her own . . .

But no one came forward, and Agnes soon became ensconced not only in Carolyn's heart but also in her increasingly bustling household. Carolyn is the founder of HUHA, and Agnes is without question the matriarch of the rescue organisation's diverse animal family: new arrivals soon learn that, even though she might be slower than them, she's to be respected.

Magnum

When the house that Magnum's owner was renting was damaged in the February 2011 Christchurch earthquake, they fled to the safety of his owner's parent's home in Twizel. Magnum's owner eventually moved on again, but Magnum stayed behind. He'd grown to quite like Twizel, and it's not hard to see why. At first, Magnum was left in sole charge of the house, as his owner's parents (now, somewhat reluctantly, his owners) were out of town. Unbeknownst to one another, they'd each asked someone to come and feed the cat—which meant that Magnum's bowl was being filled to the brim by two separate people, and he was eating twice as much as usual. Magnum thought it was excellent. He ate it all up.

When Magnum's new owners at last returned home, it was to find a very fat, happy tabby waiting to greet them. He looked like he'd been blown up with a bicycle pump, and was so rotund that he couldn't lie on the ottoman without falling off the side. He rolled rather than walked, and people (very unkindly) would often point and laugh at him. With time and the return to a more appropriate diet, however, Magnum returned to his usual only-a-little-bit chubby, beautiful self.

Magnum's new owners had initially told their son that they'd take care of the pudding kitty for a while . . . and that was it! They'd recently lost a dearly beloved cat, and had made the decision not to adopt again, as they no longer wanted the commitment of arranging care for when they were away travelling. That was all before they met and got to know Magnum. He soon captured their hearts and the idea of rehoming him was banished forever. Magnum now sleeps on their bed and is a talkative and cheery addition to their abode.

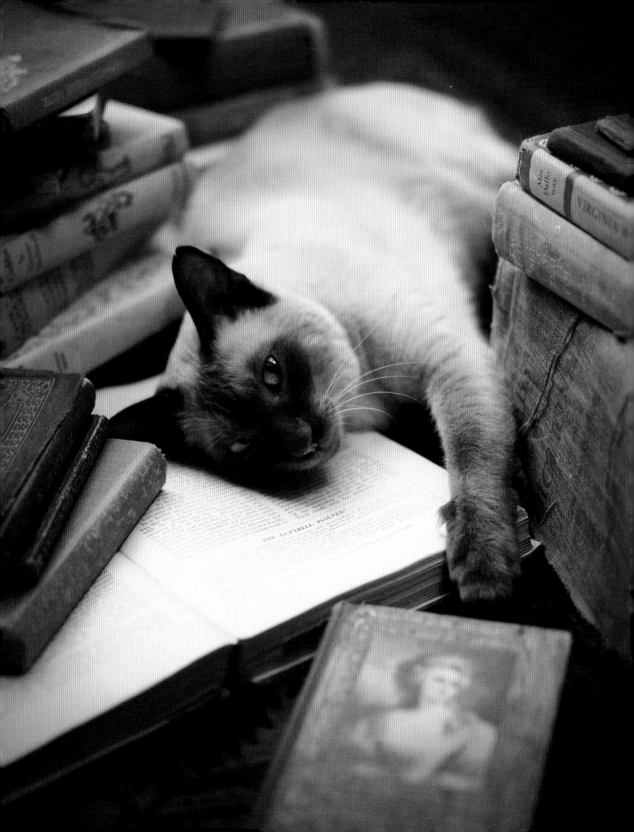

Lucinda

For many years, Time Out Bookstore, in the heart of Auckland's Mount Eden village, had a resident Tonkinese called Oscar. He was very grouchy and spent most of his time curled up asleep among the books in the front window. Oscar was utterly adored by customers from near and far. When he passed away in 2010, store owner Wendy knew that Time Out would never be the same without Oscar . . . but it also wouldn't be the same without a cat. It felt as though something was missing.

So, a few months later, Wendy adopted another Tonkinese, this time a little lady. Time Out ran a competition to choose the new arrival's name, and the winner was Lucinda—in tribute to her predecessor and after the book *Oscar and Lucinda* by Peter Carey.

Whereas Oscar spent all of his time among the books at the shop, Lucinda has proved to be more of a part-time princess. When Wendy leaves for work in the morning, she'll open her car door for Lucinda. If Lucinda feels like going to work too, she'll jump in; if she'd rather stay home, she does just that. When she does grace the store with her presence, she'll promptly take up position in her basket on the table with the new releases, or on her 'throne' (the chair behind the counter). Woe betide any staff member who might have thought to plonk their bottom there; they're promptly kicked off.

Coco

Our animal companions give so much to us—love, loyalty, comfort—that we should offer them nothing but the same in return. Sadly, every now and then you hear a story of just the opposite; a story of cruelty so absurd and unjustified towards an innocent creature that it's difficult to believe that what you're hearing is true.

One July day in 2016, Coco's owner found a trail of blood leading to the front door, and at the end of that trail was their beloved family chocolate Siamese. Coco had been shot—deliberately, as it turned out, by a neighbour—and had managed to crawl all the way home with a badly shattered and profusely bleeding front leg. Coco lives in a semi-rural area of Wanaka, in the South Island, and had presumably gone wandering in search of a rabbit and found himself on the neighbouring property.

At first, the local vet attempted to save Coco's injured leg, operating on it several times and keeping it in a cast. However, it eventually became evident that this wasn't going to be successful, and Coco's owners and the vet were left with little choice but to amputate the leg. Several months of rehab later, Coco slowly began to get the hang of walking and functioning without one leg, but it was not an easy journey—and an often upsetting, heartbreaking one for his family, who could not make sense of why someone would do this to their pet.

The man who shot Coco was charged with ill-treatment and cruelty under the Animal Welfare Act, and had to cover Coco's vet bills, but he did not face firearms charges. His behaviour was condemned by the SPCA and local community groups.

Coco's life may have had its challenges, but he hasn't let that keep him down. He's now well on the road to adjusting to his new way of life, and returning to his fine form. He's a very social cat and loves to visit the guests staying in his owners' B&B. (He has even been known to sleep in bed with them if they're keen!)

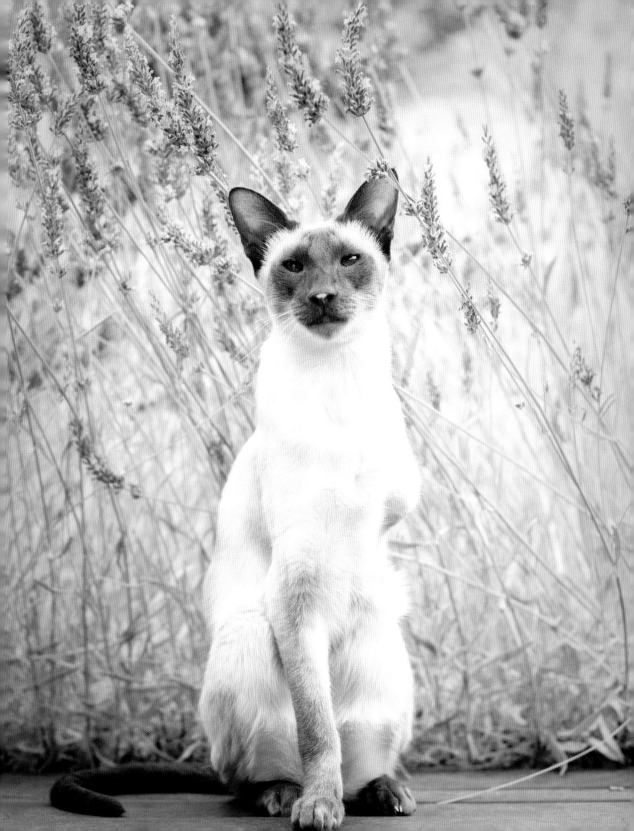

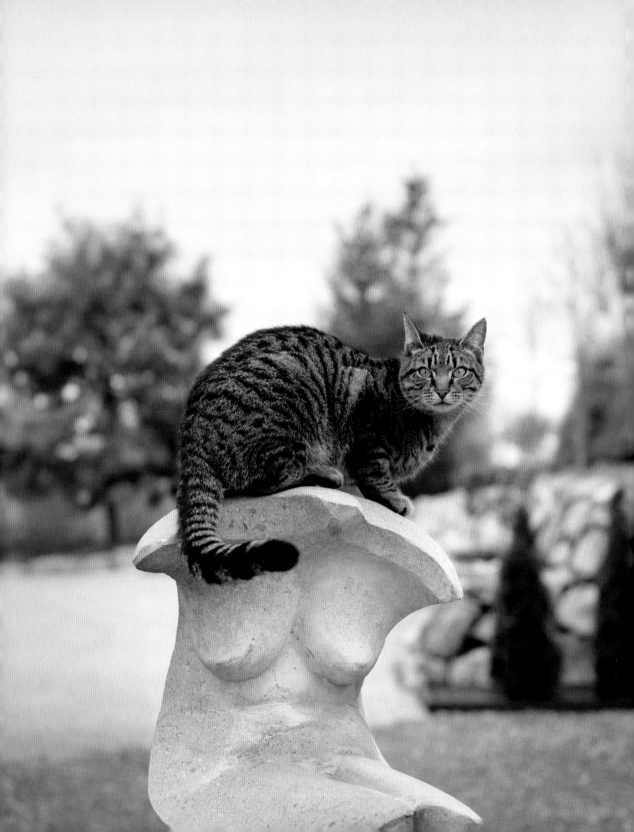

Taylor

Right from the moment he joined his family as a six-week-old kitten, Taylor was full of personality. He spends his day as a sculptor's cat, following Nelson sculptor Michael MacMillan around as he does his work. Taylor will always seek out the best vantage point for watching Michael work, and often this is perched on top of or inside another sculpture. He doesn't seem to mind the dust and noise one bit; all he really wants is to be by Michael's side. Taylor checks out every visitor to the family's gallery, greeting each of them and sometimes even hopping right into their cars. His favourite trick is to hide behind a bush or sculpture then come rushing out to pounce on unwitting passersby, and he does this daily, without fail.

Taylor is inquisitve, mischievous, a stealthy hunter and a loving companion. Dogs might be man's best friend, but Taylor is Michael's.

Primrose

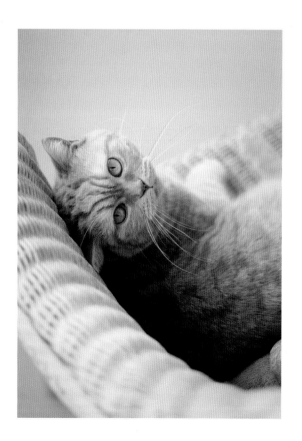

Primrose is a chatterbox. She'll talk to anyone who will listen—the postie, children walking past on their way to school, the humans she lives with. It's just unfortunate that humans are a bit of a dense lot: Primrose often has to yell and enunciate her demands *very clearly* in order to make herself understood. But clever Primrose has come up with a series of expressions that are simple enough for even the slowest of humans to understand—a soft mew for 'hello', a louder cry for 'pay attention to me' or (if it's been raining) 'dry me', and a guttural yowl for 'dog!' She's even got a special cry for 'brush me!', but, just to be on the safe side, she sits next to her brush to make that one extra clear. You never can be too sure with humans.

Primrose has an ongoing feud with the sparrows and thrushes that invite themselves on to her back lawn. Someone keeps putting bread out there to lure the birds to the grass . . . and Primrose can hear laughing (is that the neighbours?) when she goes out to chase the birds away. She can't imagine what's so funny; she's doing everything right. First she stalks the birds (while chattering at them, of course), then once she's in position she barrels at full speed towards them. One day she'll catch one, she's certain.

Valrhona

Eleven-year-old Valrhona—who is more commonly known by her nickname Moo—is a survivor of the 2010 and 2011 Christchurch earthquakes. This brave little chocolate Burmese took shelter in her house as the earth shook and the world fell apart around her in that first terrifying quake, while her human family fled to safety. The next day, they returned, unsure of what had happened to their little Moo—and found her hidden in a washing basket in the laundry.

Since that first awful earthquake, Moo and her humans have moved home three times, and have been persistently troubled by aftershocks and devastating destruction. When the 22 February earthquake struck in 2011, Moo was frightened witless by

the enormous rocks that began to rain down around her and her home. She disappeared, and her family didn't find her again until the next day, this time inside the badly damaged house. She was sitting in her basket in a room that had a gaping hole in the exterior wall.

Moo had always been a nervous little cat, and unsurprisingly the stress of the earthquakes and their aftershocks has only amplified her qualms. She watches her humans closely, never leaving their side, and sleeps in bed with them every night. She retains her lovely, sweet nature, however, and enjoys her home comforts, always seeking out the sunniest spot and taking time to sit in the window and nosily spy on the neighbours.

Nylah and Charlie

Pals Nylah and Charlie share one thing in common: they are both outrageously cute. Outside of this similarity, though, the pair couldn't be more different.

Charlie (front) is an independent spirit: he'll often disappear on extended hunting expeditions, returning only late at night to have a nibble on the food that's been left out for him. If it's wet or cold, he might come in a little earlier (and sneak a cuddle or two), but otherwise he prefers the unattached lifestyle. His owners are certain of one thing: they'll see him when they see him.

Nylah, on the other hand, is a little home body. This placid and gentle little cat is very content to sleep inside all day. The closest she ever gets to hunting is casting a glance out of the window at the birds jumping around in the trees.

Chincy, Hooper, Prince André and Mirry

When Chincy's owner first met him, he was just twelve weeks old and on death row at the SPCA. No one wanted him, for the mere reason that white cats can be more prone to cancer than other cats. Chincy went home with his new owner that day, and would remain utterly devoted to her—almost as though by way of thanks for saving him—for the remainder of his thirteen years. Chincy's owner fosters motherless kittens, and whenever a new furball would arrive Chincy was first on the scene to help get things tidied up—by pinning the kitten down and washing it thoroughly from head to toe, whether the kitten liked it or not!

Chincy's best friend was Hooper, and the pair would often sleep snuggled up

together, white fur blending in with ginger. Hooper is a big gentleman who tries hard to hold position as top cat at home, but lets himself down badly every time flea-treatment and worming time comes around. Rather than facing things with calm and grace, he runs in terror instead. When Chincy died, Hooper grieved for him immensely, becoming ill and losing a lot of weight. But time is, as they say, the healer of all things, and he gradually returned to his former health and learned to adjust to life without his best bud.

Chincy wasn't the only one to help 'mother' foster kittens; he had a sidekick in Prince André, a talkative and personality-loaded 'Snowshoe' cat who also loves to help take care of the babies who pass through their home. Prince André came here from Australia (the first Snowshoe cat to be exported here from that country), and his owners were quite anxious about how he'd handle the long-haul flight.

However, they needn't have worried: far from being freaked out by the long-haul aeroplane trip, they found him at the airport peering out of his cage, eager to see what excitement awaited him next. While he can be quite mischievous (sometimes in a funny way; sometimes not so much), it's impossible to feel mad at him for very long. One look from those beautiful blue eyes is enough to melt even the sternest heart.

Mirry is another keen aide in the mothering department, but she's got more personal reasons: she was a foster kitten herself. In fact, it's a miracle she is still alive at all. The day that she was born was also the same day that she lost her mum, and all her kitten siblings, too. At one day old, she was alone in the world, with a slim chance of surviving another day—but this determined little soul beat the odds, and survive she did. Now, she's an affectionate and cuddly part of this happy feline family.

Casper

Sixteen-year-old Casper is named after
the friendly ghost, because when he was
a kitten you would hear his little footsteps
approaching behind you, but when you
turned round he'd be nowhere to be seen.
A sneaky little ghost cat.

Max

Max loves a good adventure, and is especially fond of following his owners up the road when they go out horse riding. He'll accompany them for as far as a kilometre before turning around and returning home. Whenever one of his owners is down with the horses, Max will be right there, too, rolling around the arena and getting in the way. He's an extremely passionate boy, often waking his owners up in the night to express his devotion by rubbing his face on them and giving their noses 'kisses'.

Peanut

When Peanut's future owner, who was seven years old at the time, arrived at the SPCA to choose a kitten, Peanut decided to take things into his own paws. As she sat in the enclosure, watching the surrounding kittens, Peanut walked right up to her and jumped on to her lap, as though to say, 'Why not save yourself the time and pick me? I'm meant to be your cat!'

His confidence paid off, and he went home that day with the glorious full title of 'Peanut the Smasher'.

Now, several years later, Peanut and his young owner are still best mates. For a while, their family lived on a lifestyle block in the country, and the two would set out together to check on the rest of the menagerie: the chooks, the sheep and the pony. Peanut was always very happy to tag along, but he drew the line at riding on the pony; that was for the humans, and no amount of coaxing would convince him otherwise.

As he's grown older, Peanut has become less of a 'smasher' and more of a snuggly old man. He will cuddle up to most people, unless his bestie is in the room; then he only has eyes for her.

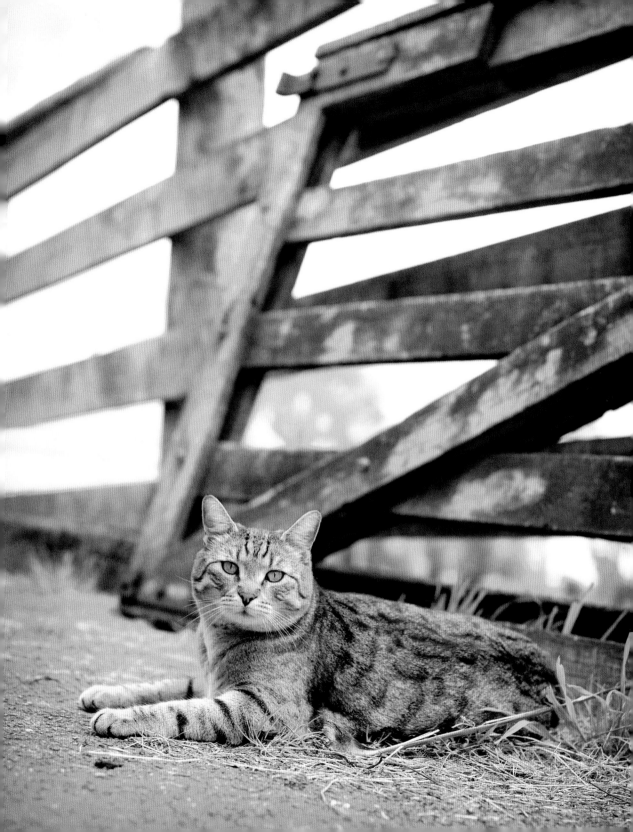

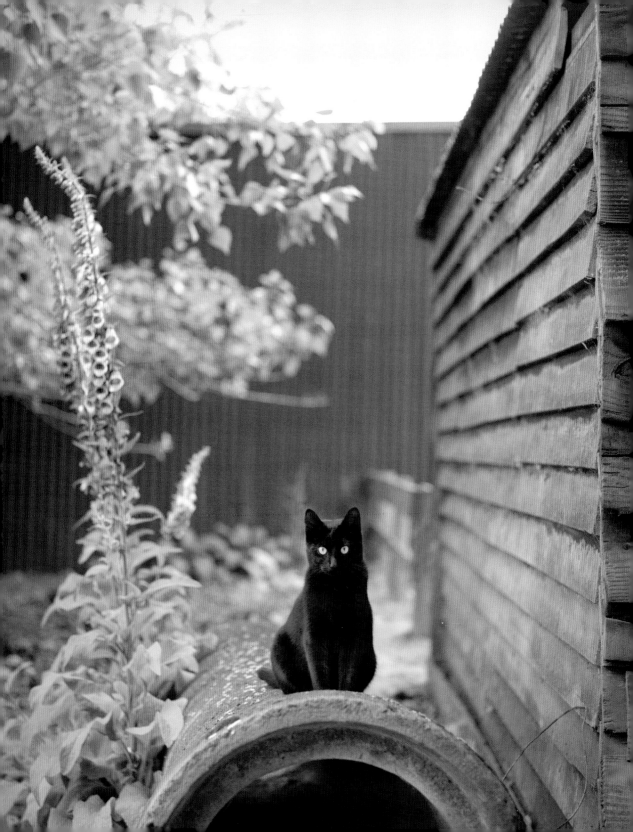

Boo

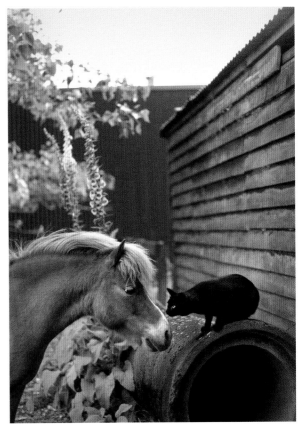

Whoever came up with the notion that black cats were an omen of bad luck was sorely mistaken, and had clearly never met Boo. This little cat first set eyes on her future family one cold winter's day. She'd been abandoned in a box along with her litter mates, and all of the kittens but her had found new homes. The moment her new owners met her, they knew she'd be a welcome addition to their family; she was so young that her eyes were still blue, and it was impossible to resist that piercing gaze. Due to her sleek black appearance, they figured this little witch's cat couldn't have anything but a spooky name—so Boo it was.

You couldn't find a more kind-hearted cat than Boo. She's extremely gentle, never scratches, and is only too happy to curl up quietly and let the events of the day unfold around her. Even those who claim to not be a 'cat person' find their hearts melting when they meet Boo, and she's got enough affection to share with every person and creature she meets. She loves to follow her owners on walks around the farm, saying hello to everyone she sees along the way.

When she first arrived at her new home, she was stepping in on someone else's territory. Billy the farm cat, who is a bit of a gruff fellow even at the best of times, wasn't exactly chuffed about the newbie. But the tiny black kitten brought something out in him, and before long he had decided that Boo could do with some mentoring and took it upon himself to teach her how to mouse.

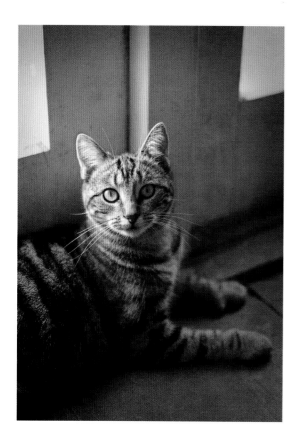

Teapot

into the passenger seat of her little yellow truck, and taken along for the ride. If any of them woke or wriggled, their caregiver would pull the truck over, tend to the mewling, then carry on with her animal-saving tasks.

Before long, the kittens got bigger and more mobile, so their time in the truck came to an end. They were placed in foster care, where they thrived and were soon all weaned on to solid food. One by one, these lucky extra-toed kittens were rehomed with wonderful loving families—all of them, that is, except for one.

Teapot was the runt, and even though she had the spirit of a lion her little body had some troubles. But she was a gutsy wee girl, always eager to play with her litter mates and doing her best to keep up with them. In fact, she was always trying to keep up and play with any animal! It wasn't long before Teapot found her forever home, too: back in the arms of her original caregiver at HUHA, where she is constantly surrounded by animal companions to play and have fun with, including Tiki the kaka.

Take a close look at Teapot's little feet. Notice anything special? She's got an extra toe, which is otherwise known as being polydactyl.

Teapot's beginnings in this world were a little rocky: at one week old, she and her litter mates (all of whom are polydactyl, too) were left orphaned when their mum was hit and killed by a car. They found themselves in foster care, and were bottle-fed for their first few weeks. Their caregiver was a full-time rescuer for HUHA, who often found herself called out at all hours of the day and night, so the tiny kittens were tucked into a carry basket, buckled

Mistress

Have you ever wondered where all the partners to all your socks go when you do the washing? Ever been tempted to imagine that there might be some kind of sock monster hiding behind the washing machine gobbling one sock at a time? Well, Mistress's owners soon realised they did indeed have a sock monster in their house. It wasn't hiding in the laundry, though. It was a furry monster, this one, with two pointed ears, long whiskers and a swishy tail.

Mistress gave herself away with the sock-stealing business. She'd burrow deep down into the washing basket to fish them out, then as soon as she got her teeth into one she'd make a noise that said to everyone within earshot 'I've got a sock!' before waddling towards one of her humans, sock dragging between her legs, to show off her catch. She'd even scale the clothes rack to get to them, if the job demanded it. And, if no one was at home, Mistress would simply leave a trail of socks down the hallway for them when they returned.

It was very good of her.

Simba

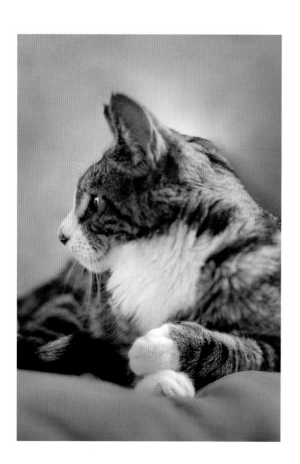

Simba's owner thought she didn't like cats, but that was until she found an eight-week-old tabby chewing on a corncob in her back garden. For a few nights, she fed the little cat, managing to eventually catch it in a borrowed cage. She took the kitten to Queenstown Cat Rescue, who informed her that it was a stray—and also that it was a boy, not a little girl as she'd thought. They told her they'd try to find him a forever home, but in that short space of time the tiny tabby had already worked his magic: Simba went back home with his new owner, a human who had never thought she'd be a cat owner but had fallen for him. Before long, Simba had become her little sidekick and it was impossible to imagine life without him.

Then, one November evening, Simba failed to come home for his nightly cuddles. His food hadn't been touched. His owner knew something wasn't right, but her partner tried to reassure her that Simba would show up. The next morning, Simba still hadn't appeared.

On her way to work, she got a phone call from a friend.

'Hey, have you seen Simba this morning?' her friend asked tentatively.

Simba's owner went cold. 'No,' she replied.

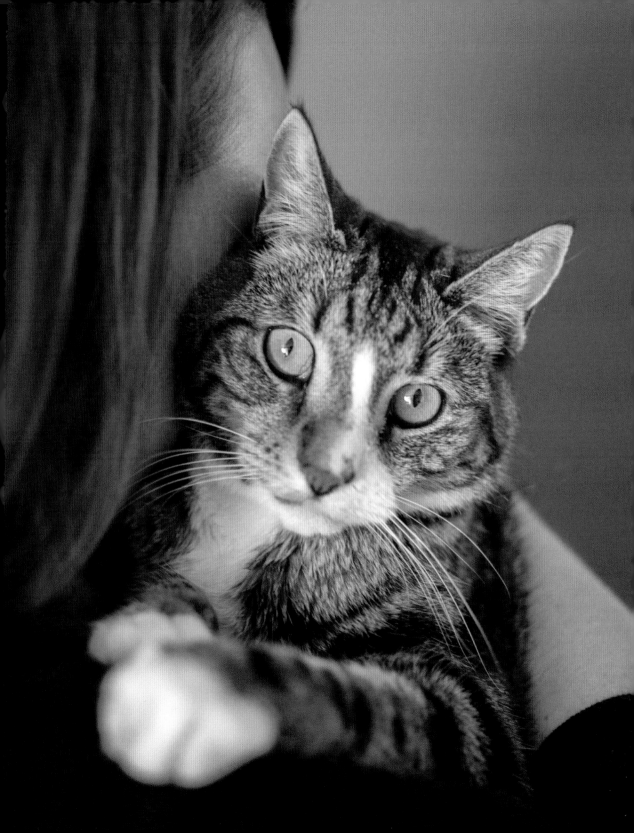

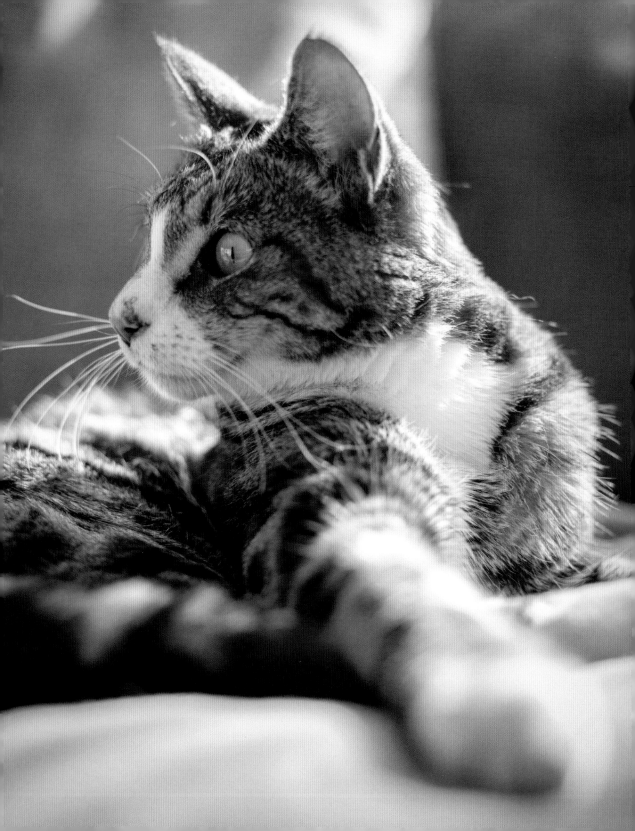

'You'd better pull the car over,' her friend said, before explaining that she'd just seen a post on a local Facebook group: someone had found a cat, and it looked a lot like Simba. In the post, the person said they had hit the cat with their car and were about to take it to the local vets. They wanted to find the cat's owner as they were concerned 'it could be curtains for him'; he was in a very bad way.

Simba's owner rushed straight to the vets. Before long, a shocked-looking young woman arrived with a cat in a cardboard box covered by a waterproof jacket. One look was all it took for Simba's owner to confirm it was indeed her beloved little man.

He wasn't moving.

The vet immediately took the cat into the examination room. Simba's owner followed, so frantic she forgot to say anything to the woman who had brought Simba in.

'He's had a massive brain injury,' the vet said in the most sensitive way possible, as he looked over Simba. 'I can't feel any broken bones. It looks like the full impact was to his head. It's extremely swollen.'

Simba's owner didn't know what to say.

'OK.' The vet sighed. 'I think our best bet is to give him some pain relief and see what happens.'

There was nothing to do but wait.

Later that afternoon, Simba's owner returned to the vet clinic, expecting to hear the worst. As soon as she walked into the room where Simba was being kept, she called his name, and he tried to get up when he heard her voice.

'That's a good sign,' the vet told her. 'It means he recognises you. It's still early days, but let's continue the treatment.'

Slowly, ever so slowly, Simba began to recover. It turned out that his leg had been dislocated and all the ligaments were torn;

it wasn't clear how affected his eyesight was, and he seemed to be doing everything backwards. His owner went to visit him every day, sitting on the floor with him and showering him with love. After what felt like weeks, the vet told her they wanted to try to save his leg, but that doing so would mean a big operation to pin it.

'We haven't done that type of surgery here at the clinic before,' the vet explained. 'Plus, Simba's so small that we may have to change our plan of attack once we get in there and see what's going on.'

The alternative was to send him to a vet in Christchurch or Invercargill, but Simba's owner wasn't keen on that. What's more, she'd come to trust the local vet, and felt that they understood how much the cat meant to her; she knew they'd do everything within their power to take care of him. The surgery was a success, and Simba was confined to 'cage rest' for

six weeks afterwards—but, he somehow managed to keep escaping! A sign that his characteristic cheekiness was returning.

Around this time, Simba's owner called the young woman who had taken Simba to the vets to thank her, and invited her to come to see how well he was now doing. She wanted the young woman to see what an amazing thing she had done that night: not many people would pull over to pick up a cat that they had hit with their car, let alone do everything that the woman had done to try to save Simba's life. As Simba's owner discovered, this young woman had immediately pulled over and jumped out of her car when she'd realised she'd hit something. When she saw it was a cat, she had panicked and called the police; they gave her the number for the after-hours vet. Over the phone, still standing on the side of the road, she described the condition of the cat to the vet, who told her it didn't

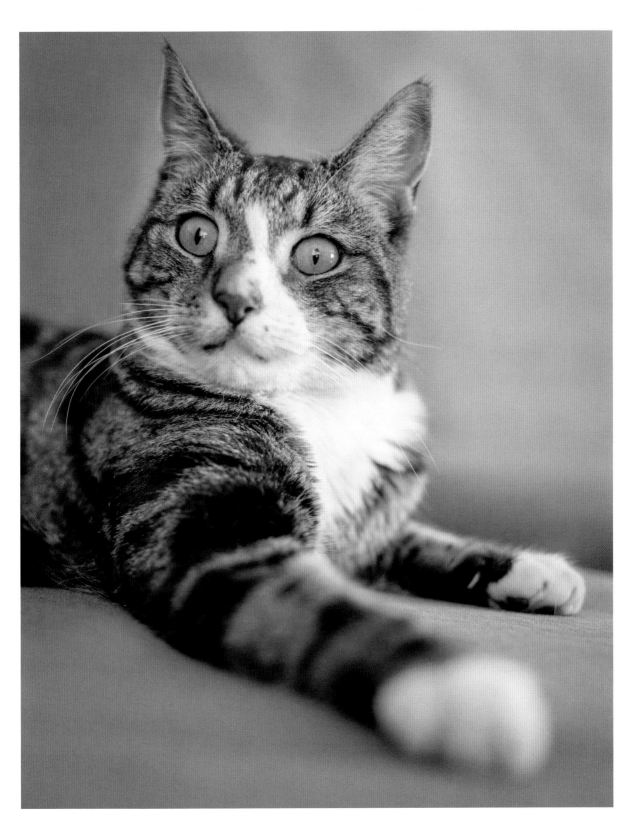

sound like it would last the night. 'The best thing you can do,' the vet told her, 'is take it home and keep it warm.'

But when she went to get back in her car with the injured cat, she realised her car battery had gone flat; she'd been so concerned about Simba that she hadn't even remembered to turn her car lights off. She eventually made it home, and spent the night outside on the balcony with Simba, as her flatmate had a dog inside. In the morning, she saw he had survived the night, and she knew she had to take him to the vets. She got her car jump-started, got bitten by Simba who was obviously in pain, and eventually made it to the vet clinic.

Simba's owner had already been grateful to this woman for saving her cat's life, but when she learned the lengths she had gone to it warmed her heart. Simba will never be the same again, but his character is in no way dampened. If anything, he's got even more personality now! A couple of his teeth are broken and they grind when he yawns, his pelvis is twisted so that he sits at a strange angle, and his eyesight is a little questionable (he doesn't know how far away things are sometimes). Despite all this, he still climbs up his human's legs for cuddles and is more adorable than ever.

Everyone who meets this little cat falls in love with him, and at the end of the year that he had his accident the Remarkable Vets at Arrowtown gave him the Big Save Award, for his love of life and his owner's commitment to him. He's nicknamed Ninja Cat, and it's more than apt: as well as being adept at escaping from his cage even with a pinned leg, he's got a knack for climbing out of barely open windows and getting through the cat door when it is locked. He really is a bit of a James Bond: if you watch him closely, you'll can see him eyeing up all possible options available to get from A to B.

Wilson

When the rowing course manager for South Island Rowing, a man called Trevor Wilson, found a cat and her litter at Lake Ruataniwha in South Canterbury he hoped she and her friendly little family might stick around the rowing club and keep the undesireable number of mice down. Unfortunately, the cat and her kittens moved on—but they left one tiny furball behind, all alone. Trev decided the best thing to do would be to take her to the vet so she could be rehomed—he had a dog that wasn't into cats, so he couldn't take it home himself.

On his way to the vet clinic with the kitten, he called into the local building supplies yard, where the adorable kitten walked straight into the waiting arms of one of the humans working at the yard. She turned to her dad, who runs the yard and has a cat of his own. 'Don't you reckon Fluffy could do with a wee mate?' she said, and her dad just sighed. He knew there was only one answer to that question. From that moment on, the kitten became the resident feline at Mackenzie Country Building Supplies. The children in the kitten's new family chose her name for her—Wilson, obviously. (They could hardly call her Trev, could they?)

Wilson now sleeps on top of the printer in the building supplies office, and she *loves* humans, especially small ones. Visiting sales reps will often bring her cans of special food, and customers search her out whenever they're in the office.

Tahi

For fifteen years, Tahi was a cherished and adored member of his family, and though he's much missed he's also left behind many fond memories. As a cheeky kitten, he got into the habit of pinching toys off the dog next door. His owners would often come home to find one of the dog's little balls or squeaky toys deposited on the floor for them. In his younger days, he would stand on people's feet, let out one warning meow, then launch himself up into the air and into their arms. He always expected them to catch him for a cuddle, and on a few occasions managed to alarm unsuspecting visitors, who got a heck of a fright to find themselves suddenly holding a cat!

One day, his owner took some blue cheese out of the fridge in preparation of friends coming over, and left it on the bench to come to room temperature. When the friends arrived, however, the blue cheese was nowhere in sight. A quick search soon revealed its whereabouts: Tahi was under the bed (his 'secret' hiding place) happily munching his way through the mouldy *fromage*.

Every night at bedtime, Tahi would join in on the kids' story-time, snuggling into the bed between them, ready for the evening's tale. When the kids were really little, Tahi was extremely tolerant of their 'affections', letting them lug him around the house, lie on him and snuggle up to him. He loved all the attention.

Sometimes the boys would sleep overnight in the treehouse, and Tahi didn't want to miss out. He'd climb up the ladder and join them. There was just one problem: he couldn't climb back down. When he was ready to leave (which was often in the middle of the night), he'd simply meow loudly and insistently until one of the boys got up and carried him down the ladder.

Tahi wasn't supposed to sleep in the bed under the duvet cover, but when it got really cold in winter he would try his luck anyway. Sometimes he'd manage to sneak under the blankets before anyone noticed, but he always gave himself away with the loudest-ever contented purring. His owners would often wake up in the middle of the night to find a furry head on the pillow next to theirs; Tahi had tucked himself in, just like one of the people.

Zippy

The first time Zippy's family met him, they walked into a room in which three kittens were tearing around, using the lounge furniture as a confidence course. The ring-leader was Zippy.

He might not be the world's friendliest cat—if he's full of food, he does what he likes and will try to take your arm off if you disagree—but he does have a penchant for playing cricket and can be pretty cuddly . . . if he wants something, like food or the chair you're sitting in.

Grunt

Little Grunt got his title from the army nickname for a determined but low-ranking soldier, and it's easy to see why. At just three weeks old, Grunt and his two tiny siblings were discovered under a flax bush and taken to HUHA. The three kittens were extremely weak, and Grunt's two siblings sadly didn't survive. So Grunt was fostered into another litter, where he soon made friends with another kitten called Barry. Where Barry was shy and timid, Grunt was a social butterfly: bold, confident and a total love sponge. The two formed a firm friendship.

In his new litter, Grunt soon lived up to his name, and despite the fact that at every weigh-in he was only half the size of a healthy kitten his age he determinedly continued to grow stronger. A family visited Grunt at HUHA and decided he could come and live with them, but it was another few weeks before he was big enough to finally go to his new home.

At last, the long-awaited day came, and Grunt was put into his shiny new carry cage . . . along with his best mate, Barry. The friends had found their forever home—together.

All of Grunt's dreams had finally come true.

Chairman Meow

Meet Chairman Meow: daring, adventurous ratter extraordinaire. When this little tabby first appeared in her family's shed one summer, she watched them carefully from up high in the rafters without making any move to come down. 'If we don't feed her,' they decided, 'then she'll go back to her home.' But, though she appeared timid and unsure, Chairman Meow stayed put. The stalemate persisted for nearly a week before hunger got the better of her fear and she finally descended. This has been her home ever since—good news for everybody but the rats that had taken up residence in the shed before her.

She's a quick and effective hunter, and will go to great lengths to ensnare her prey. She once skittered along a 2-centimetre-wide board high up in the shed in hot pursuit of a rat on a truss above her—all with her back legs on the board and her front legs up above her head, trying to dislodge the rat from its perch.

Another time, a bird she was chasing across the lawn evaded her by flying into the nearest tree. It hopped about in the branches above, teasing her, clearly thinking it had got the better of her. Chairman Meow didn't pause for a moment: she scaled the tree trunk then swung out along a limb like a child on the monkey bars at school, gripping the branch with her front claws, her back legs dangling in the air beneath her. But, as she audaciously reached out with one front paw to try to snare the shocked bird, she lost her grip and came clattering down through the limbs and leaves. Approaching the ground with gathering speed, all looked doomed—until she hit the top of the children's slide, which was fortuitously under the tree in just the right spot to break her fall. She glided down the slide on her back, then skidded on to the grass. It wasn't very graceful, and it wasn't on her feet, but it was still a landing!

Sushi
and
Honey

Sushi and Honey are the queens of their domain and do everything with their humans. They'll accompany them on walks around the neighbourhood and even pop in to visit the neighbours. If no one's there (or answering the door), that's no problem—Sushi and Honey will just let themselves in through an unwatched cat door and make themselves at home. They don't actually have a cat door themselves, so nobody is quite sure how they worked out to use one in the first place but, as they say, where there's a will there's a way.

One autumn afternoon in 2014, Tintin's soon-to-be owner was out for a training ride on her bike. It was a long ride, so she was in the middle of nowhere, and thought she was totally alone—until a grey flash on the side of the road caught her eye. She slowed down, and turned her bike around. There, in the grass on the verge, a little tabby kitten was chasing cicadas. There wasn't another human in sight, so it was clear this little fellow was on his own, but as soon as the cyclist stepped off her bike the wild kitten scarpered into a pile of brambles.

So, right there in the middle of the road, the cyclist removed her top, and used it to reach through the spiky brambles and capture the kitten. There was just one problem: she had no phone signal. She stood there for a moment, wondering what to do . . . Then she remembered that her mum was due to drive along the road at some point, so she simply moved her bike to a visible spot on the road's edge, then went

and sat in the ditch with the kitten to wait.

It's fair to say her mum got more than a fright when she was driving along and saw her daughter's discarded bike on the side of the road . . . only to see her daughter climb out of the ditch a moment later, shirtless, and holding a mewing kitten in her hands!

It didn't take long for the kitten, who was christened Tintin, to begin to make himself at home. As his new human gained his trust, he grew ever more confident and mischievous. He had soon carved out a little routine for himself: bright and early, at 6.30 am, he would go to his owner's door and squeak at her until she woke up and provided cuddles; he'd then do the same thing at night before bedtime. Tintin especially loved it when the whole family was home, and before long he was joining the humans at the dinner table every night for the family meal. Every member of the family now has their seat at the table— including Tintin.

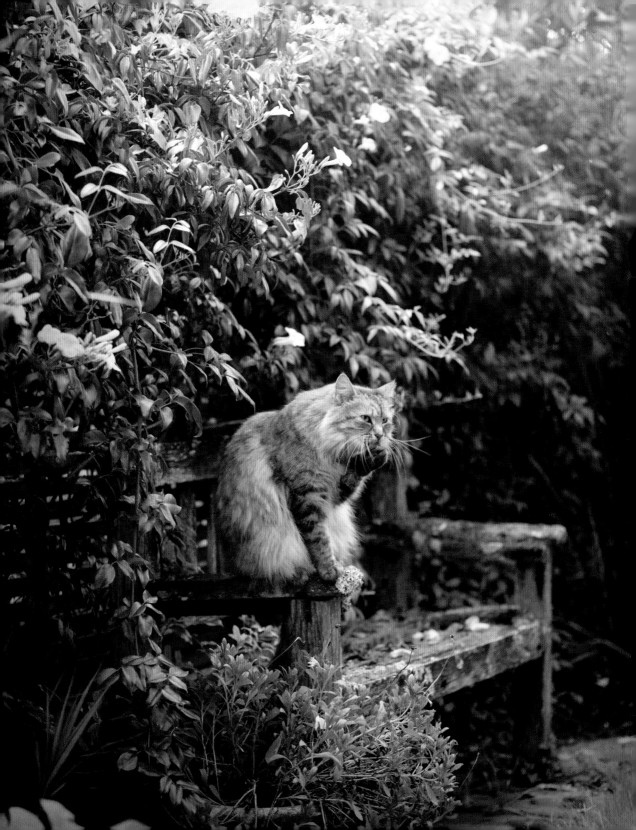

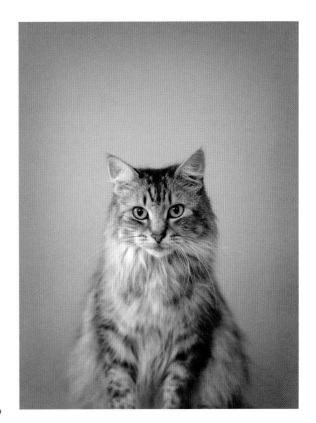

Cats are renowned for their aversion to water, but if anyone ever mentioned that to Phoenix she either a) didn't hear them or b) didn't care. She *adores* water. She jumps in puddles and chases the ripples, and loves to sit in the rain. Despite the fact she's got a perfectly good water bowl, she'll refuse to drink anything but running tap water. Whenever she's thirsty, she'll race to the bathroom, jump into the bath, and loudly demand that someone turn the tap on for her. This is all well and fine, except for the fact that her lack of opposable thumbs means she's unable (but also unwilling) to turn the tap off herself, so whoever obliges her by turning *on* the tap also has to oblige her by waiting patiently for her to finish before they can turn it *off*—and this can take some time.

Phoenix

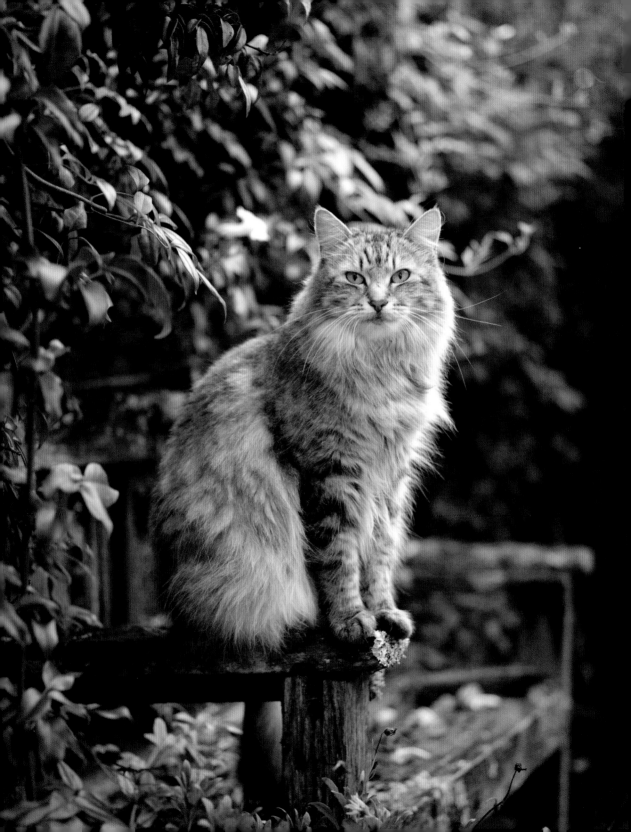

Fluffy Bum
and Ewok

Fluffy Bum (right) was eighteen months old when his owners found him at the SPCA and took him home. He came as a pair, along with a big tabby called Mister Cat, who sadly died about a year later. Not long after Fluffy Bum had settled into his new abode, his owners decided to procreate and he was joined by a couple of human babies—which suited him down to the ground, because he always loved attention. The kids would dote on him, cuddling him, dressing him up, pushing him around in a doll's pram, and Fluffy Bum loved it all. If he ever got sick of the fun and games, he'd let one of the kids know by very gently tapping them with one paw.

Though he was a prolific hunter, you'd be forgiven for thinking otherwise. He could most often be found lazing around in the sun, and his favourite spot was the chicken coop, where he would sit patiently with the chickens to wait for the scraps to be tossed in.

During his time, he saw a number of other animals come and go, but none captured his heart quite like the little Maltese shitsu Pippa. Fluffy Bum and the pooch became fast friends, playing and chasing each other about the yard.

One of those newcomers was Ewok (left), who was discovered as a kitten on the side of the road by a family friend. She was tiny and terrified, and her frightened little face peeking out at the world looked just like the famous creatures from the *Star Wars* trilogy. She might have been small, but she was fierce. Just like Fluffy Bum, she became great pals with Pippa, and could often be found curled up fast asleep with the dog.

Ewok, too, was a great hunter, but her exploits proved a bit more showy than Fluffy Bum's. One day, her owners found her clinging desperately to the side of the chicken coop, waiting for a bird to fly past. As soon as one did, she threw herself out into the air in a giant leap after it. She tolerated the chickens, though—as long as they were there, she had the chance to join in on the scrap action.

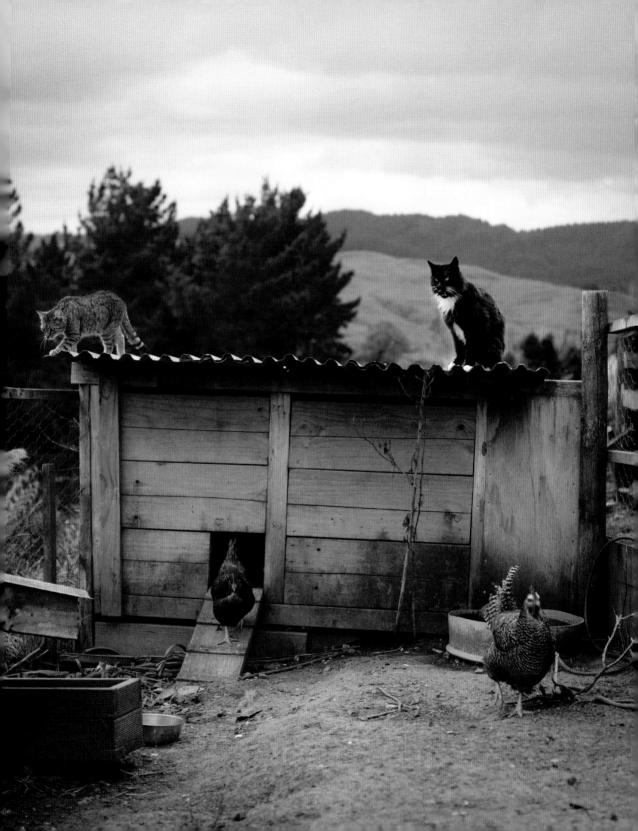

Riley

One afternoon in 2015, when Riley's soon-to-be owner was out walking her brother's dogs, she saw a furry blur dart across the track ahead of her. The dogs immediately pricked up their ears, then scurried off excitedly in the direction of the movement, and she ran after them. There, hidden under a bush and peering out at them with the biggest, brightest blue eyes, was a tiny grey five-week-old kitten.

That night, this wee dude found himself in a warm home, with a full belly and loving company (his owner named him for 'living the life of Riley', after all). Things couldn't have been better! And, as it turned out, Riley's timing couldn't have been better, either. He soon became his owner's best bud and emotional support for her throughout her partner's—his dad's—battle with cancer, and would even accompany her on visits to the hospice. His happy, furry little face was always a comfort to both of them in difficult circumstances. And, when his dad passed away, Riley was right there beside his mum to care for and love her.

Riley sleeps in his owner's bed every night and loves going on trips in the car. Unlike many cats, who hate even the mention of the C-word, Riley will happily sit on your knee and look out of the window at the passing world. He doesn't really like to be left out, and will follow his owner everywhere, including outside to visit the sheep and run along with the dogs.

Number One

When Wanaka Wastebusters, a reuse and recycling store on the edges of the mountain town, opened back in 2000 it wasn't long before Number One the tabby and her sister, Number Two, had made themselves at home among the second-hand treasures. Unfortunately, Number Two was an adventurous soul and met an untimely end on the main road outside Wastebusters. Number One was devastated and cried for days after the loss of her sister.

Number One is unfailingly welcoming to all visitors to the reuse shop, and is very happy for anyone to pat her—even if they are still learning how to do it! A lot of young children have learned how to properly pat a cat with lessons from Number One, which sometimes involve her fur being stroked the wrong way, small hands trying to pick her up upside down, or her being chased around the shop. No matter the child (or adult) she's faced with, though, Number One is always dignified and polite. Some visitors even come to the shop simply to have a cuddle with her.

In her younger days, she was an amazing ratter, but now she's semi-retired and prefers to spend most of her time snoozing. She's got something of a gift for finding the most comfortable places in the whole shop—buried in the linen, in the middle of the table set with full cutlery for Christmas, inside a box of books. Sometimes the staff make funky beds up especially for her, and for a while she chose to doze in an old suitcase on a sheepskin alongside a travel photo.

Mr Puss

One day before Mr Puss had been officially adopted by his human family (he was still just a 'visitor' to their house at that stage), he accidentally found himself shipped off to the local dump in a neighbour's van. As soon as the van door was opened, Mr Puss was out and away like a rocket. All the neighbour saw was the furry flick of a disappearing tail and Mr Puss was gone.

Back at home, a day or two passed and the family Mr Puss had shacked up with grew worried. They popped around to the neighbour's to ask if he might have seen the cat.

'Oh . . .' The neighbour looked sheepish. 'Um, yeah . . . Well, he's at the dump. But he should find his own way home, eh?'

Naturally, Mr Puss's hosts were furious that this was the first they'd heard of his relocation. It was the middle of winter and the world was frozen, covered in hoar frost. Mr Puss would be cold and frightened out there alone. Not to mention the fact that the dump was set with pest traps that would be the end of Mr Puss if he went near them.

At the dump, Mr Puss's carers stood outside the seven-foot perimeter fence and rattled a tin containing cat biscuits. Almost immediately they heard a croaky 'Meow!' that sounded like it came from a lifetime smoker and up popped a very cold Mr Puss. The rest is, as they say, history. Mr Puss went home with his family that day and his status changed from that of 'visitor' to 'permanent resident'.

It wasn't long before Mr Puss had his humans—and many of their friends— wrapped around his little front paw. One time, his family left him in the care of a friend while they went away on holiday, and Mr Puss came home one morning limping badly. The friend took Mr Puss to the vet and came away with some antibiotics. As the story goes, Mr Puss was quite sore for a few days, so of course he *couldn't* sleep outside as he normally would: he *had* to come inside and sleep in the bed with the family friend, and he required an extra dose of affection, too. This was all well and fine until the day before his family arrived home. Unbeknownst to Mr Puss, he was being observed when he jumped down from the couch, his limp having magically disappeared—but the moment he spotted the family friend watching him he instantly began to limp again in a rather exaggerated manner.

Max

Max is a biter. Not a cute, little-bit-of-rough-and-tumble, all-in-the-name-of-fun sort of a biter, but a shooting-pain, blood-and-tears biter. His family delivered him to HUHA Otaki in a state of defeated distress: they adored Max, and they wanted to care for him, but they were also terrified of him. Their home had become a warzone, with Max the invading army and the hallway the frontline. It was impossible to even enter the hallway without facing one of Max's unmitigated assaults: claws would be drawn, fangs exposed and no exposed human skin was safe.

Max's family had reached their wits' end. They couldn't live like this anymore.

So, knowing that HUHA was a no-kill shelter with a commitment to addressing grievous behavioural issues such as Max's, they handed him over. Their best hope was that HUHA might have some success where they had only come away with punctured flesh. They hoped HUHA could save Max.

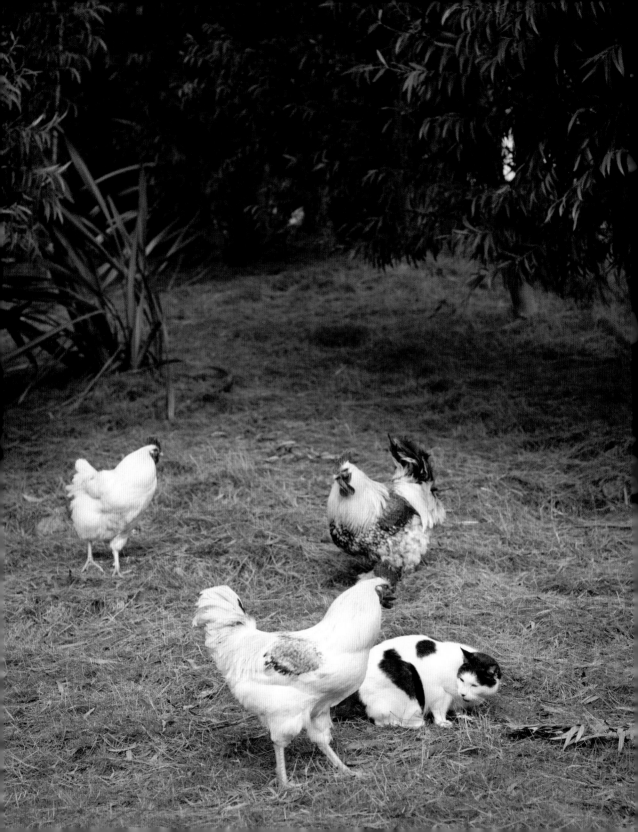

The staff at HUHA has seen many a biter, and were confident that they could address Max's nasty habit, as they had with other cats, by changing his environment. They would dig deep to find the root of the problem—in Max's case they presumed it was boredom—then work to find a suitable new home that would accommodate the lifestyle Max required.

But Max proved a tougher nut to crack than they had ever come up against. No matter what the HUHA staff tried, Max continued to bite.

In between the moments of bloodshed, he was the epitome of a chilled-out companion cat: attentive, gracious and most often to be found lazing in the sun, purring loudly. But, without a moment's warning, it was as though he became a cat possessed: his eyes would glaze over and, completely unprovoked, he would launch a ruthless attack. More and more people began to question the merits of keeping Max, as he was so clearly dangerous to those around him.

Five years later, however, Max is a cat reformed. He is content and happy, biting-incident free and the king of his particular castle—and what a glorious castle it is. HUHA, despite the seemingly insurmountable difficulties, did not give up on Max. Instead, true to their commitment of finding a safe solution for all animals where possible, they took a step to the side and forced themselves to think outside of the box. What could they do to help Max? How could they possibly ensure that he had a happy, safe life, a life in which those around him were also happy and safe?

For Max, the answer turned out to be simply to give him an extremely unique job. HUHA whisked him away to become the groundsman at HUHA's rescue zoo in Kaitoke. There, his job is to watch over the ex-circus monkeys, sunbathe with the wallabies and wait for breakfast with the roosters and peacocks. Visitors to the rescue zoo are told Max's story as he politely greets them and walks them around the property, with a friendly headbutt and a purr.

Theodore Papadopoulos

They say pets choose their owners, and in the case of Mr Theodore Papadopoulos (Theo to his pals) that's most certainly true. When his owners came to meet him and his litter mates, he was the only kitten who came straight over to them and wanted to play.

Now a grown-up kitty, Theo remains the household fur baby. He has his patience tested at times by Mabel, the overly exuberant Labradoodle who is convinced that Theo is her bestest buddy in the whole wide world. The friendship isn't always reciprocated by Theo, who has been known to give Mabel the occasional swipe when she takes things too far; he's not always in the mood to have his ears licked or be chased around the yard, as fun as Mabel finds such antics. But, when Theo thinks no one is watching, he will smooch alongside Mabel and give her a friendly wee flick with his tail. He gives her just enough attention to keep her coming back for more . . .

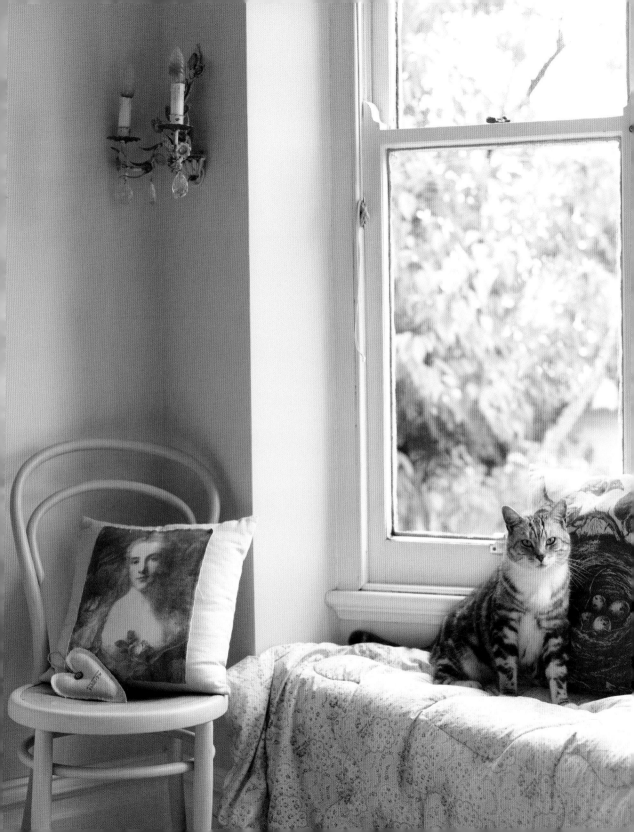

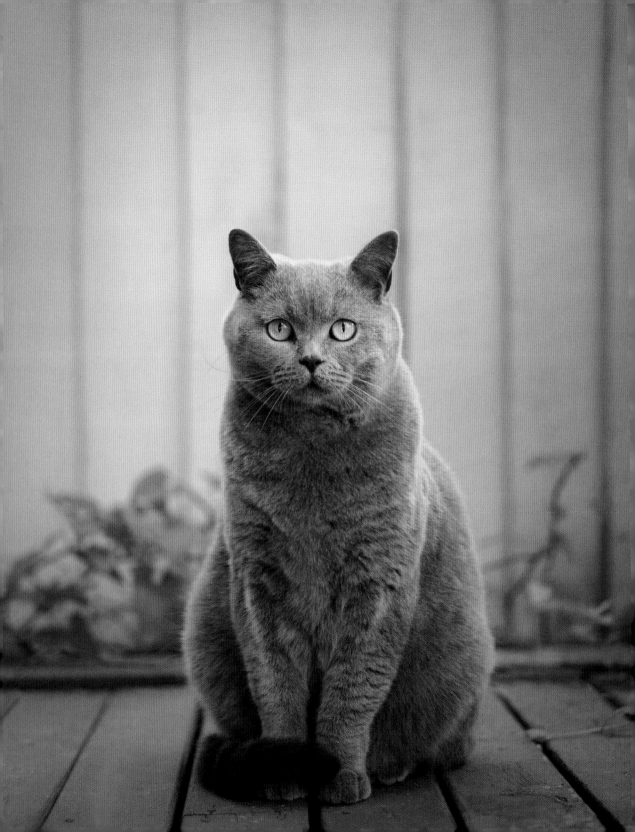

PussPuss

PussPuss would like to tell you there's a better reason behind the name he's been given than there is, but that's just not the case: it is the result of a deliberately silly nickname that stuck. It seemed like such a ridiculous name for such a big, muscly grey cat that his owner couldn't resist. She thinks it's hilarious; he, not so much.

Someone told his owner that British blues have an unfortunate tendency to get obese quickly, so he also suffers the repeated indignity of being put on a diet. PussPuss has developed three quite effective techniques for addressing this lapse in his owner's judgement, and will make his displeasure known if his bowl is empty any time from 3 am.

1. **Foot attacks.** PussPuss launches a concerted and deliberate assault on his human's feet through the duvet while she's sleeping. This is heart-attack material for her. *Efficacy rating: A*

2. **Pillow trotting.** PussPuss runs back and forth across his owner's pillow in the wee hours, pulling her hair as he runs by. A major battle inevitably ensues. Sometimes his owner is foolish enough to try to ignore him, but PussPuss has found that seven times across the pillow is all she can stand. *Efficacy rating: A–*

3. **Body bouncing.** PussPuss uses his owner's body as a trampoline. He might be chubby, but his precision is second to none. He makes a flying leap onto the bed, directly at the human's body, and then off again. Then he repeats until the desired outcome is achieved. *Efficacy rating: A+*

PussPuss has extremely expressive eyes and ears, and he'll use them to make his feelings about all manner of disgusting human behaviour known. If his owner farts, for instance, he'll pin his ears back to the top of his head and glare at her with an expression of utter disdain. She always apologises, but he refuses to accept it. She should really know better by now.

PussPuss is a terrible tease, and spends a lot of time deliberately ignoring his owner. He'll go and lie in the sun, his belly facing tantalisingly upwards, but when she tries to approach to pat him he'll scarper off. The problem is that she's realised she can catch him unawares if she only waits until he's asleep: then, he's anyone's. You could pat him all day long (and he'll never admit it to anyone, but he actually quite likes it).

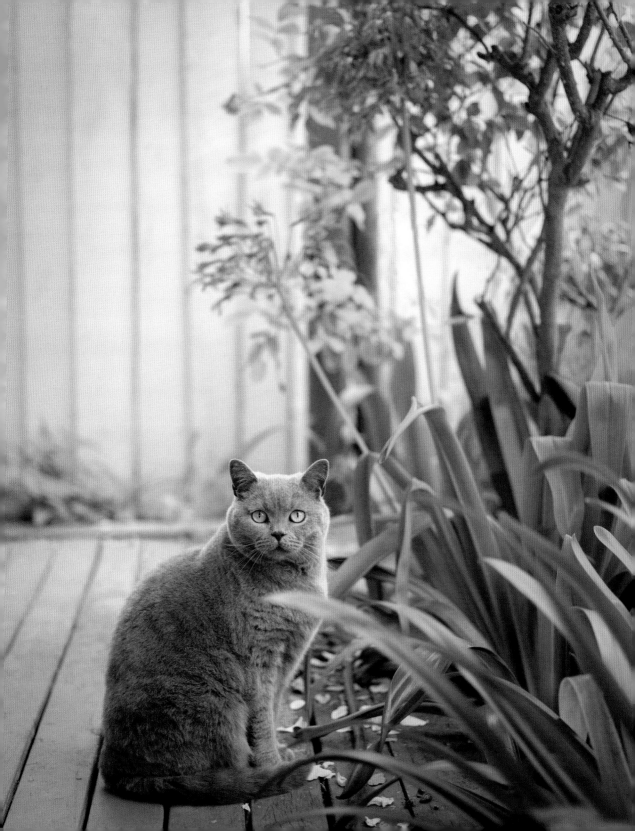

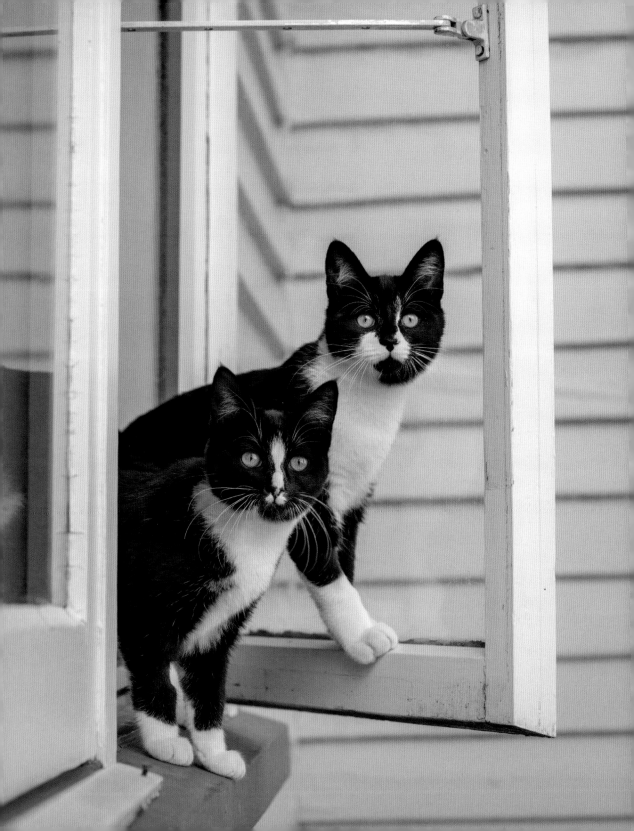

Monkey
and Bertie

———

One day in a state of emotional vulnerability after losing her beloved cat Periwinkle, the future owner of this pair saw them curled up together in a pet store. It was like a sign from above: these kittens were obviously meant to come home with her, and it was clear that they shouldn't be separated.

Oh dear, she thought as she drove home, the little babies mewing from the cardboard box in the back seat. *What have I done?!*

This feeling sat with her for more than a few days, as—unlike with Periwinkle and her other cat, PussPuss—she didn't feel an immediate bond with the new arrivals. Fearing she'd made an awful mistake, she put the word out that the cats were available to a good home . . . but

the minute some friends said they'd take them she realised just how attached she had become to them. Monkey and Bertie became firm fixtures in her life.

Monkey (who has the black nose) is the more adventurous of the pair, and even though he's a big, independent boy he still crawls up onto the bed every night and tucks himself in for a little cuddle. Bertie loves feather toys, and if she's nowhere to be found it's usually because she's up a tree.

Brother and sister are joined at the hip. It's as though they don't know where their own body finishes and the other one's starts; they'll nap on top of one another and seem unaware of whose fur they are licking at any one time. It doesn't really seem to matter; it's all one and the same to them.

Frost

About seven years ago, dapper Frost was hit by a car and came away with a broken pelvis. He had to be kept confined inside a small cage for six weeks while his bones mended, and even though he's a bit stiffer in his back legs it doesn't seem to have dampened his enthusiasm for jumping and climbing wherever he can. He's got an incredible ability to get through any window, no matter how high up or difficult to reach. One day, his owners found him working diligently on a particularly uncooperative window in their house: he had to lever the window open with his paws, which required him to spend a good fifteen minutes leaping up the wall to grab onto the window almost two metres above with his paws. He lost his grip about five times, but he wouldn't give up—and his perseverance paid off, to the astonishment and amusement of his audience.

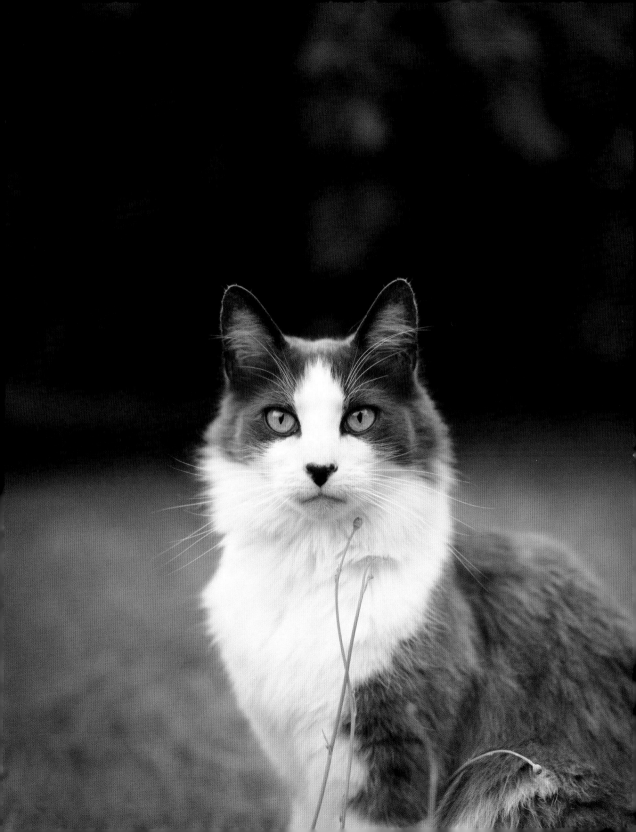

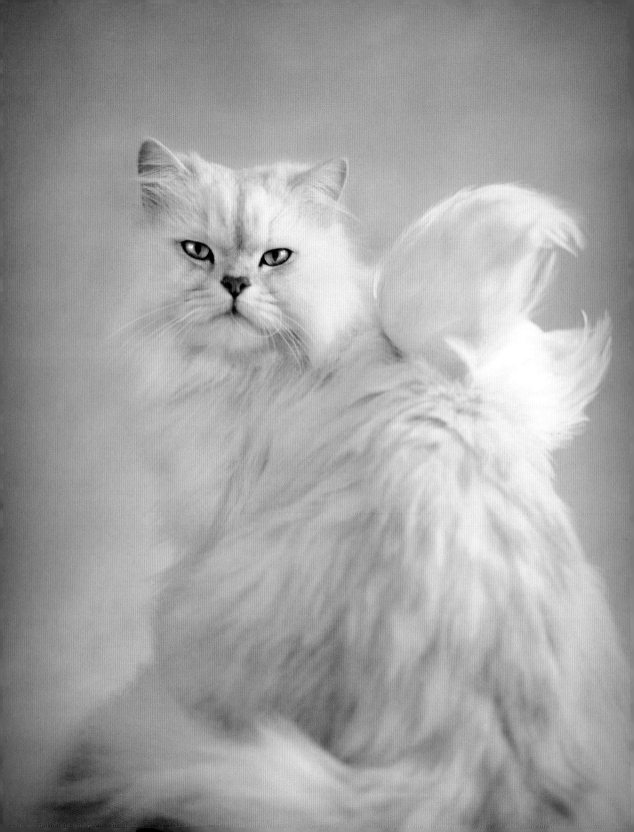

Rai

As a kitten, this fluffy white cloud—a Chinchilla Persian, to be precise—was full of beans. It's lucky he was so cute, because it made it impossible to stay mad at him when he whirled up and down the hallway in the wee hours of the morning. Rai grew into a gentleman of enthusiastic appetites—for fun, adventure and attention, but most of all food. He is always on the prowl for snacks, claiming that he's constantly *starving*. Unfortunately, he suffers from a sensitive tummy: he's highly allergic to many commercial cat foods, so now lives on a completely raw diet (but is sometimes found testing the neighbours' windows in case they've left him some biscuits!).

Rai loves going for rides in the car (especially if it means he might get an extra tidbit to nibble on), and more than once his owner has had strangers wave out to her to stop. 'Do you know your cat is in the car?' they'll ask, a concerned expression creasing their features, when she pulls over. Rai will usually be watching them intently through the passenger's window.

Rai, who is named after a famous Brazilian footballer, is completely cool with dogs, and often provides his services as a mentor to pooches who need to be trained to be more cat-friendly. Rai just rolls his eyes at his canine counterparts, some of whom can have a bit of an attitude problem, and doesn't flinch at any silly business.

Like many cats, Rai has a finely honed 'anti-cat-person radar', and is always able to pick the person in a room who *doesn't* want him anywhere near them. He'll home in on these cat-haters and makes it his personal mission to convert them to the feline-loving side of life, forcing himself on to their lap, begging for attention and just generally wearing them down until they can't help but adore him. It works every time.

Major
Tom

Somehow, through unhappy circumstances, Major Tom found himself a gnarly old neighbourhood stray. It was easy to tell from his friendly nature that somewhere along the way someone had loved him, but he had ended up on the streets, un-neutered and unwanted, fighting to survive. As he visited houses around his neighbourhood, looking for scraps of food and a sunny spot to rest his weary bones, the residents and their cats grew annoyed. 'That darn nuisance stray,' people would say. 'Someone ought to get rid of him.'

Eventually, the residents had had enough. He was taken to a local vet, who then passed him on to a cat-rescue organisation. The cat rescue desexed and vaccinated him, then put him up for adoption.

Meanwhile, the founder of HUHA had received a phone call from a movie producer asking if she could be tempted to dust off her animal-wrangling skills to train a cat for an upcoming film role. She didn't agree immediately—it had been many years since she'd worked as an animal trainer, and these days she was a hundred per cent focused on animal rescue.

But then she remembered how many lives her work in that long-ago field had helped her to save. She had a policy to work only with rescue animals where possible, and thought about the potential this provided to take an animal out of a sad situation and teach them to be confident and strong. Training a rescue animal for a role not only enriched them and taught them life skills,

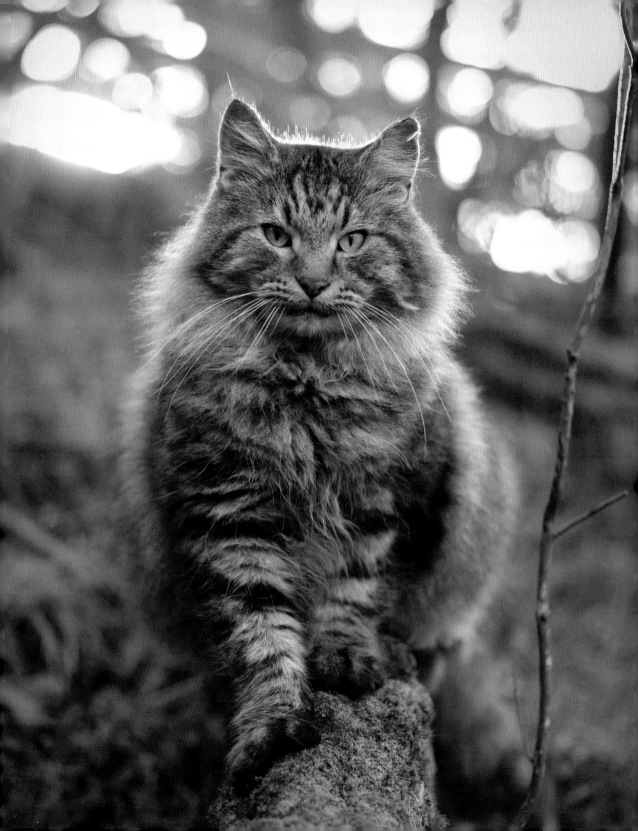

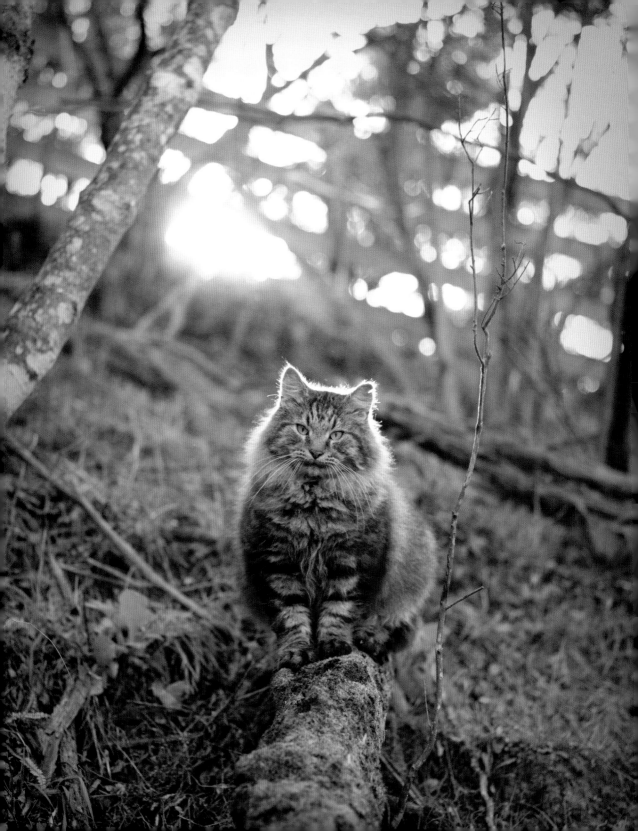

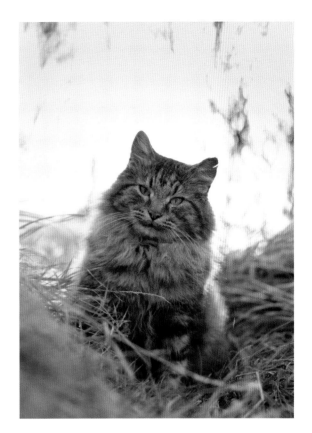

but it also—importantly—gave them a new chance. It would give them hope. Even after the filming was over, they would be guaranteed an enriched and loving happy-ever-after.

So she said yes.

But first she had to find a cat to rescue and train.

The next day, as she walked into a dank and smelly local rescue cattery, she explained to the elderly volunteer who she was and why she was looking for a cat, but her words fell on deaf ears.

'They are all fifty dollars,' the volunteer said. 'Which one do you want?'

Alarmed by the fact that there was no pre-adoption interview or home visit, she simply pointed at a scruffy medium-haired tabby, handed over the money and took him home. David Bowie had passed away that day, so she christened the dilapidated cat Major Tom.

As it transpired, Major Tom—also called Thomas—was born to be a star. The moment that he was granted the love, warmth and attention he had so desperately been in search of, he thrived. His coat glistened as he bounded through his paces, performing on command with the confidence and drive of the most seasoned movie veteran. He was totally at home on set and during filming, relaxed and happy as he draped himself across the actors' knees.

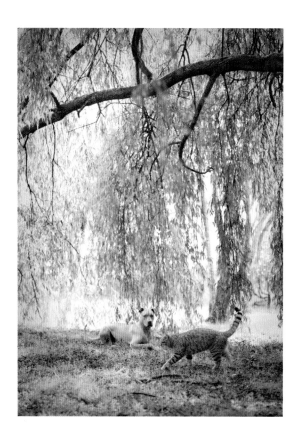

Pepper

Pepper the Bengal–British shorthair cross isn't totally convinced he's all cat; there's a fairly big part of his heart that thinks he's more of a dog.

It's understandable. Pepper has grown up surrounded by dogs, and was even a fundamental part of his owner's business, K9 Cadets, in its early days. K9 Cadets is a behavioural dog clinic, and Pepper played a vital role working with the dogs who needed to be socialised with cats. Pepper was only ever too happy to oblige: it meant that he got to spend his day running around with the pups while they played fetch, and he couldn't imagine anything better to do with his time.

As the business grew, Pepper took more of a back seat, now only visiting in the evenings and on weekends with the cat-friendly pooches. He's a super-cool cat who's completely unbothered by his doggie mates; he'll smooch up to even the most timid of dogs without giving it a second thought. He loves to be a part of the action, and if he had his way he would spend all of his days hanging out with the dogs.

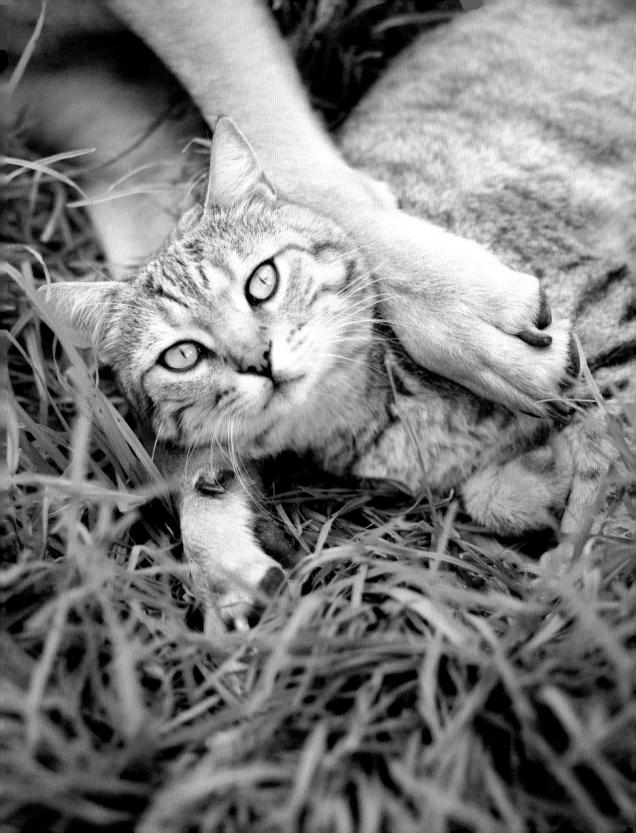

Charlie and Lola

One Easter morning a few years ago, as the future owner of these cats was reaching up in the barn to pull out a bale of hay, she was confronted by spitting, hissing balls of fluff. Some little kittens had holed up in the warmth of the hay. Before long, they'd all be captured, and taken back to the safety of their new home—much to the disgust of Aphrodite, the then thirteen-year-old feline matriarch of the house.

The stray kittens didn't stay wild for very long, and Charlie (left) soon grew into a gentle giant who dwarfs his smaller sister, Lola (right). They settled into their new life with ease, becoming patient companions for the children in their family, who they play with and often follow on walks around their twelve-acre farm.

Lola is the hunter, often bringing home large rats and mice. Charlie, for his part, is very adept at capturing the ferocious leaves that land on the lawn outside. They're all completely at home with the other animals on their farm, though they get chased by the chickens and guinea fowls. One day Charlie decided he'd hitch a ride with one of the children, who was riding the pony, Phantom, around the lawn. Luckily Phantom was completely unfazed when the cat jumped on his back, and just carried on with his trot.

Kronos

It might be hard to believe when you gaze upon this adorably ridiculous kitty's face that a former owner once tried to get him put down all because of his looks. Kronos found himself in rather unhappy circumstances when his former owner asked the vet to put him down. She'd simply decided she didn't want him anymore.

'He's perfectly healthy. I'm not putting him to sleep,' the vet said. 'Why don't you try to rehome him?'

'I already did that,' the owner apparently retorted, 'but no one wants a cat with a face like that.'

The vet was sure that the owner was mistaken. How could you *not* fall in love with that expression? 'Leave Kronos with me,' the vet told her. Surely someone would come by who would appreciate Kronos's unique looks and personality?

Kronos didn't seem fazed by the change of scene: he spent the next few days lounging around the vet clinic, totally at home. He kept an eye on the comings and goings, and would do a daily walk-by of the dogs being kept at the clinic for treatment without even batting a whiskered eyelid.

One day, the founder of HUHA visited the vet clinic. The moment she saw Kronos confidently draped across the reception desk, totally unbothered by the hustle and bustle, she knew the perfect home for him. Now, Kronos can be found ruling the roost at HUHA HQ in Kaitoke, where he shows the foster dogs the ropes of co-existing peacefully with a feline friend.

Acknowledgements

Many people help in the creation of any book, and *The New Zealand Cat* is no different. Photographing cats is quite different to photographing other animals. That's because cats are fickle, sensitive and they demand respect. So I often work alone, gaining their trust and capturing images when they are feeling comfortable. This isn't possible to do if I go into their environments with assistants and a load of gear. So, for this book, it was just me, my faithful Hasselblad camera and my feather teasers that rocked up to photograph each gorgeous kitty that shares its story in the pages of this book.

First and foremost my thanks goes to the cats and also to their owners for opening your homes and allowing me to come in and spend sometimes hours trying to capture the portraits. Most of the time I was successful! Thank you for sharing your stories and for allowing us to publish them alongside the images I have created.

An enormous and most loving thanks goes to my husband, Andy, and my daughter, Charlize, both of whom endlessly support and encourage me to do the best I can and understand that I have to spend hours out photographing—and then even more hours sitting behind the computer, editing and completing the post-production of the images to get them ready for publication. I couldn't do my job without you by my side, and you both are as much a part of this book as I am.

A huge thanks goes to Jenny Hellen and the team at Allen & Unwin New Zealand. Thank you so much for making this book a reality, and for all the time and effort you have put into producing such a stunning publication. Many thanks also for your assistance in helping me to find some of the characters included in this book. (There are a number of cats with wonderful stories who unfortunately haven't made it, but we can only blame the cats for

their uncooperative behavior!) Enormous thanks goes to Kimberley Davis for writing each story so beautifully, and to Kate Barraclough for the gorgeous design.

Carolyn Press-McKenzie of HUHA (Helping You Help Animals): I can't thank you enough for allowing me to come into your home and giving me the chance to work with the cats you have rescued—some of whom are up for adoption, and others who have embedded their paw prints into your heart and have been with you for years. The work that you and your team at HUHA does is absolutely incredible, and I wish there was more I could do to assist you with your ongoing efforts to rescue and rehome every single mistreated animal in New Zealand. I can be sure that every animal who is fortunate to find themselves in the hands of HUHA ends up well loved and in a happy forever home.

I must offer an abundance of gratitude to Hasselblad UK for supplying me with the latest H5D-50c. This camera has been such a treat to work with, and its abilities in low light conditions have made the challenge of working with cats in their natural environments so much more achievable.

Thank you also to my cousin Megan and her husband, Gary, for the days you put me up while I was working with Team HUHA in Wellington. To Debs, Perrin and my sister, Becks, for always opening your homes to me when I need a bed in Auckland, and to Richard and Linda for having me to stay during my days photographing in Christchurch—it always makes the time away from home all that more bearable when I have such friendly faces to catch up with during my travels.

Last but not least, my family: my parents, Bob and Barbara, my twin sister, Becks, and Andy's parents, Carol and Howard. Thank you for your continued love and support over the years.

List of cats

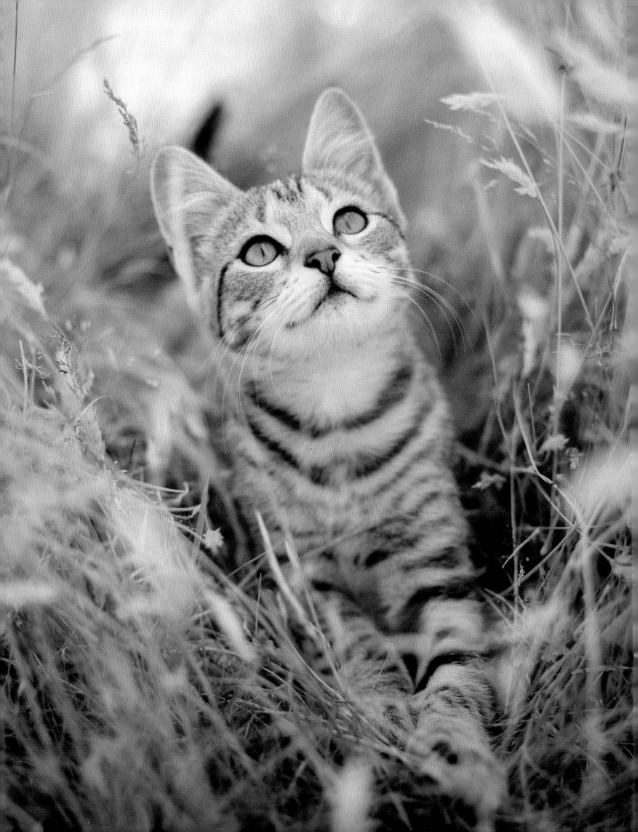

About the Photographer

Rachael Hale McKenna is a bestselling author and highly successful photographer. Her endearing images have been published on greeting cards, calendars, posters and stationery around the world, and her books have sold over 3 million copies in twenty languages.

Rachael is the author of a number of bestselling dog and cat portrait books, including *101 Salivations: For the love of dogs, 101 Cataclysms: For the love of cats, Smitten: A kitten's guide to happiness, Snog: A puppy's guide to love* and *For the Love of a Cat*. Her books about babies and children include *Baby Love: An affectionate miscellany, The Happy Baby Book, My Life as a Baby, BFF: Best Friends Forever* and, most recently, *Little Loves: New Zealand children and their pets*.

Born and raised in Auckland, New Zealand, Rachael spent a number of years until 2014 living in France, completing her French book series *The French Cat, The French Dog* and *Lunch in Provence*, then spent six months in New York capturing images for *The New York Dog*, before returning to New Zealand.

Rachael and her husband, Andy, have now settled and are living in Wanaka, Central Otago, with their daughter, Charlize, and their two-year-old Jack Russell, Flash.

About
HUHA

Helping You Help Animals (HUHA) is a
charitable trust run entirely by volunteers
that is dedicated to animal welfare and
advocacy. Founded in 2008 by Carolyn
Press-McKenzie, HUHA now runs three
shelters in the greater Wellington area, and
is an important organisation focused on
teaching empathy to the community and
providing shelter for those less-fortunate
animals that struggle to survive in today's
world. HUHA's philosophy is to encourage
the community to be proactive and take
responsibility for the welfare of animals
and the protection of our country's unique
environment. HUHA's volunteers work
actively every day to find homes and
foster care for a multitude of homeless,
abandoned, seized and abused animals.
huha.org.nz

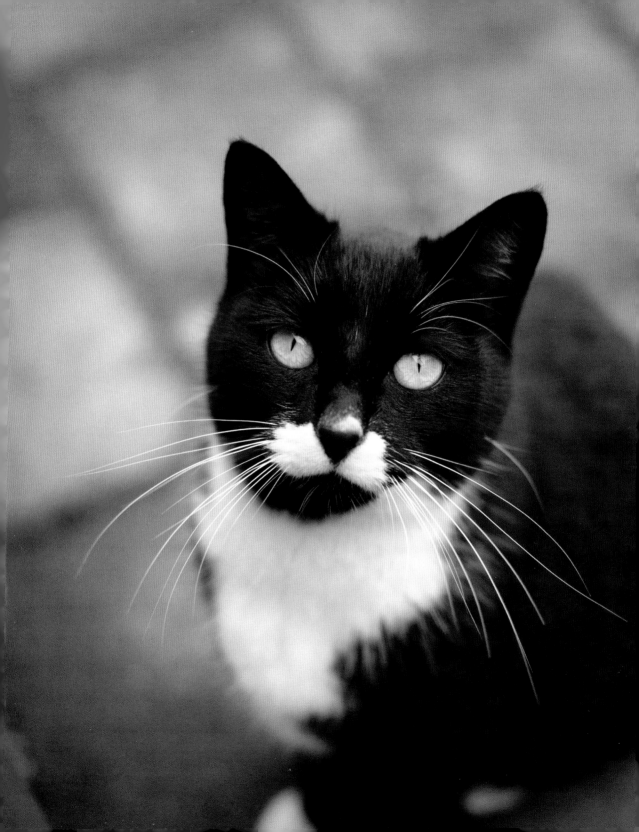

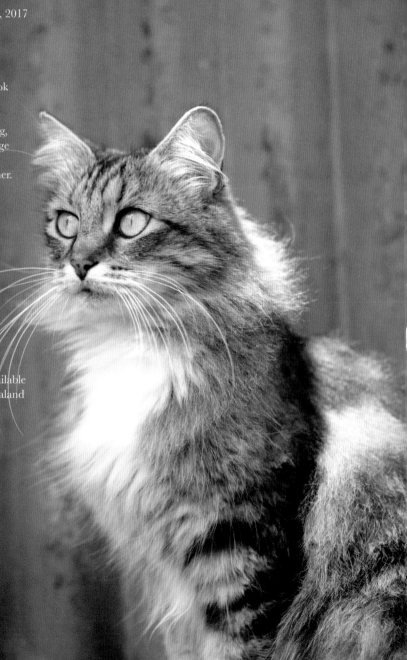

First published in 2017

Copyright © The Rachael Hale Trust, 2017
www.rachaelmckenna.com
rachael@rachaelmckenna.com
Stories written by Kimberley Davis

All rights reserved. No part of this book
may be reproduced or transmitted in
any form or by any means, electronic
or mechanical, including photocopying,
recording or by any information storage
and retrieval system, without prior
permission in writing from the publisher.

Allen & Unwin
Level 3, 228 Queen Street
Auckland 1010, New Zealand
Phone: (64 9) 377 3800

Email: info@allenandunwin.com
Web: www.allenandunwin.co.nz

83 Alexander Street
Crows Nest NSW 2065, Australia
Phone. (61 2) 8425 0100

A catalogue record for this book is available
from the National Library of New Zealand

ISBN 978 1 877505 74 4

Design by Kate Barraclough
Set in 10.5/14 pt Baskerville
Printed and bound in China by
Hang Tai Printing Company Limited

10 9 8 7 6 5 4 3 2 1

HASSELBLAD